SPECTACULAR HOMES
of the Heartland

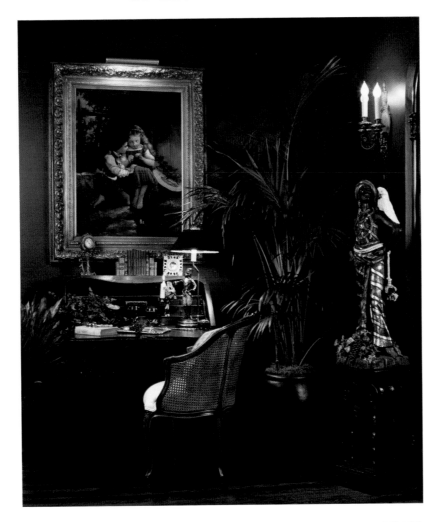

AN EXCLUSIVE SHOWCASE OF THE FINEST DESIGNERS IN AMERICA'S HEARTLAND

Published by

PANACHE
PARTNERS LLC

13747 Montfort Drive, Suite 100
Dallas, Texas 75240
972.661.9884
972.661.2743
www.panache.com

Publishers: Brian G. Carabet and John A. Shand
Executive Publisher: Steve Darocy
Senior Associate Publisher: Martha Cox
Designer: Mary Elizabeth Acree

Printed in Malaysia

Distributed by Gibbs Smith, Publisher
800.748.5439

PUBLISHER'S DATA

Spectacular Homes of the Heartland

Library of Congress Control Number: 2006930748

ISBN 13: 978-1-933415-12-3
ISBN 10: 1-933415-12-6

First Printing 2006

10 9 8 7 6 5 4 3 2 1

Previous Page: Debbie Zoller, Zoller Designs & Antiques, Inc.
See page 113 Photo by Rick Stiller

This Page: Jennifer Fischer, Major Designs, Inc.
See page 37 Photo by Bob Greenspan

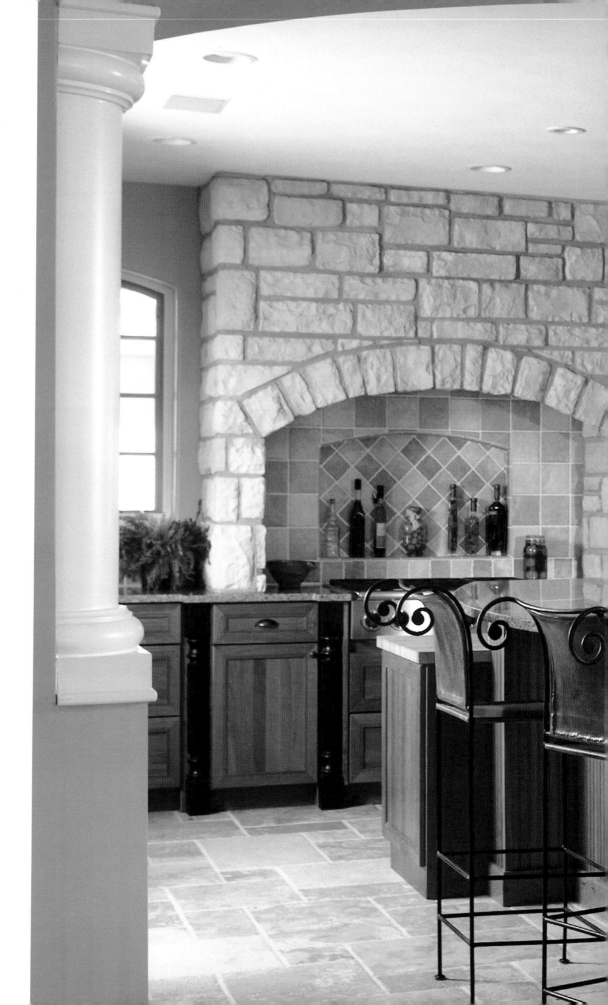

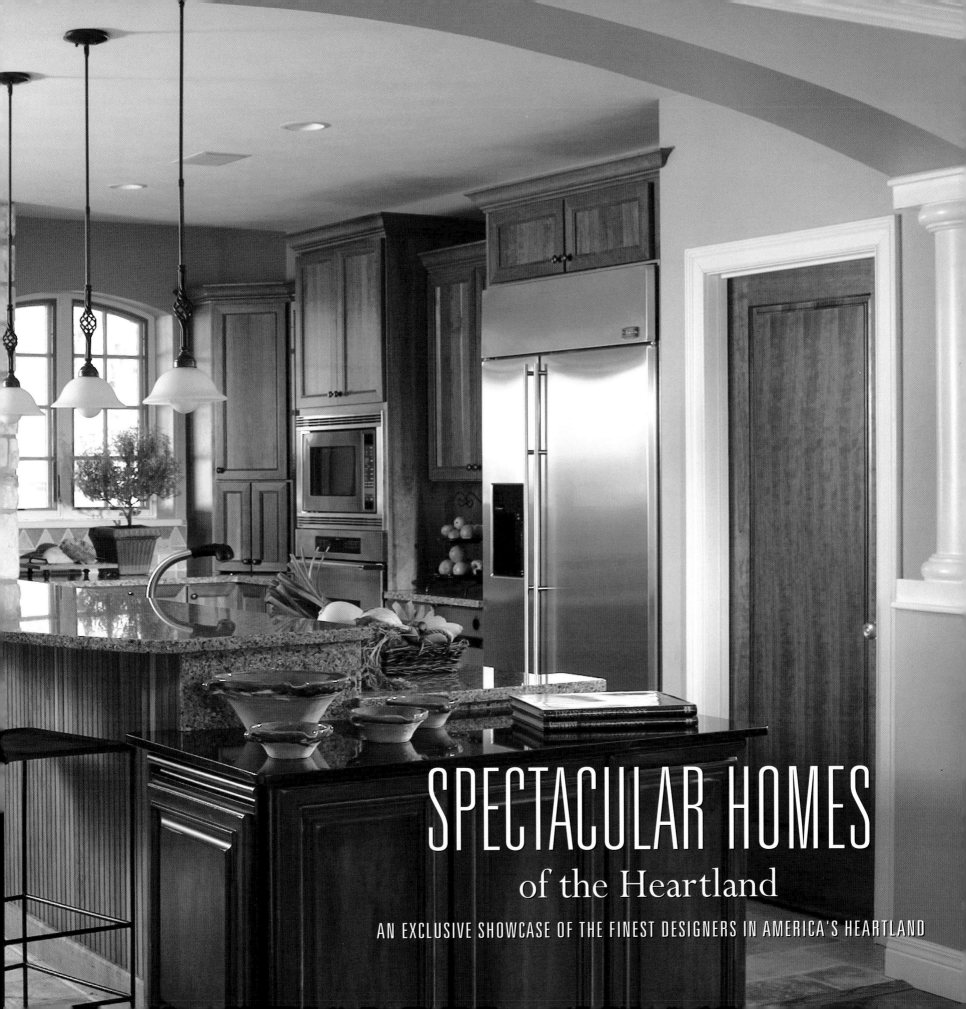

SPECTACULAR HOMES

of the Heartland

AN EXCLUSIVE SHOWCASE OF THE FINEST DESIGNERS IN AMERICA'S HEARTLAND

Spectacular Homes of the Heartland is a collection and sampling of the most talented interior designers and decorators in the heart of America. As you move through their portfolios, I hope that you gain inspiration to make your own home spectacular.

The Heartland holds a certain southern charm that you would expect. I have met with designers all over the country yet the designers in the Heartland hold a special place in my heart. Thank you to all of the designers who welcomed me with open arms into this astounding profession. I am truly impressed by the kinship everyone shares within the design community. I am also astounded at the work you accomplish with an easy-going attitude.

My goal in selecting the designers in this book was to portray the broad range of talent that each designer holds. I am always amazed at the scope of design each designer is able to tackle. There are not enough pages to print all of their work in just one book! If you see something that catches your eye, I would like to encourage you to contact the designer you admire. This book is just a sample of each designer's unique talents.

My thanks to everyone who has been a part of this journey. As always, I thank my wonderful husband Dan for his support and holding down the fort in my travels as I visited the most beautiful homes in the Heartland. I would like to extend my special thanks to my superb production team: Mary Elizabeth Acree, Jennifer Lenhart, Laura Greenwood and Beth Gionta. Your dedication has produced a fabulous book!

Welcome to Spectacular Homes of the Heartland!

Martha Cox

Senior Associate Publisher

This book is dedicated in loving memory of Robert S. Cisar, Jr. by his fellow Oklahoma designers and all who loved him and admired his work.

"The goal is to generate timely-produced design solutions that express the personal design style of my clients."

-Becky Berg

TABLE OF CONTENTS

DESIGNER JOY TRIBOUT, JOY TRIBOUT INTERIOR DESIGN, page 95

Heartland

AN EXCLUSIVE SHOWCASE OF THE FINEST DESIGNERS IN AMERICA'S HEARTLAND

HARI LU AMES

Embellishments Interiors

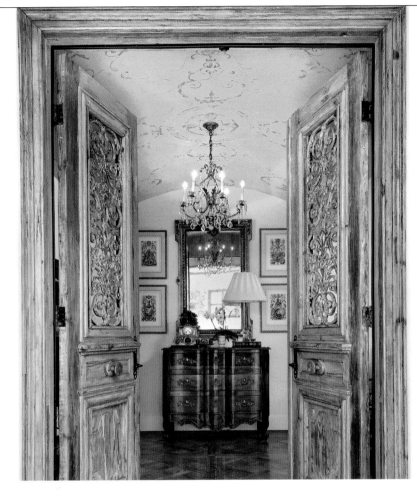

RIGHT
Reclaimed Parisian doors open into the entry hall which is composed of Parquet de Versailles floors and a frescoed barrel vaulted ceiling.
Photograph by Gene Johnson

LEFT
"Absolute Black" granite and tumbled marble backsplash flank the Lacanche range.
Photograph by Gene Johnson

Some designers are trained in school; some by the world around them and some by a prior profession. Ten years ago after a career as a registered nurse, designer Hari Lu Ames began a new career based on her enduring passion for design.

Owning and managing two retail locations, she also provides interior design services to an ongoing clientele. She fills several vignettes in south Tulsa's Windsor Market with decorative accessories, art and furniture. Her midtown Cherry Street shop, Embellishments, is housed in the building owned by prominent designer, Charles Faudree (see pg. 25), who is well known for his masterful application of the charm and beauty of the Country French style.

Tulsa, the city that Hari Lu and her husband adopted 25 years ago, has also offered inspiration because of its rich cultural heritage, lush rolling hills, old trees, and architecturally significant homes, many dating from the oil boom of the 1920s.

Her family's home is French inspired, with a dressy kick in its crystal chandeliers, rich upholstery fabrics, carpets, draperies, and imaginative accessories. She calls it a "city house." The overall feeling, however, is

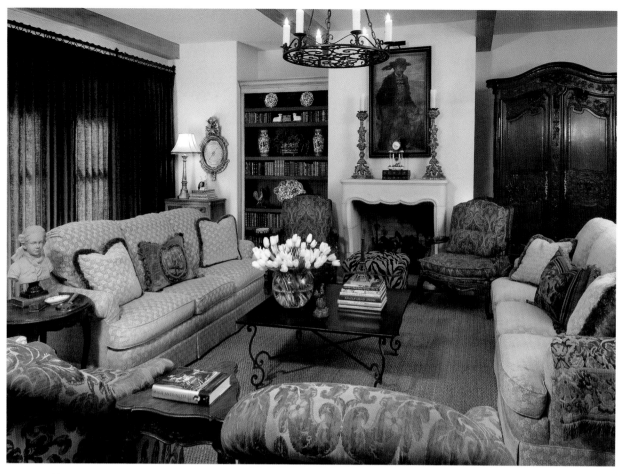

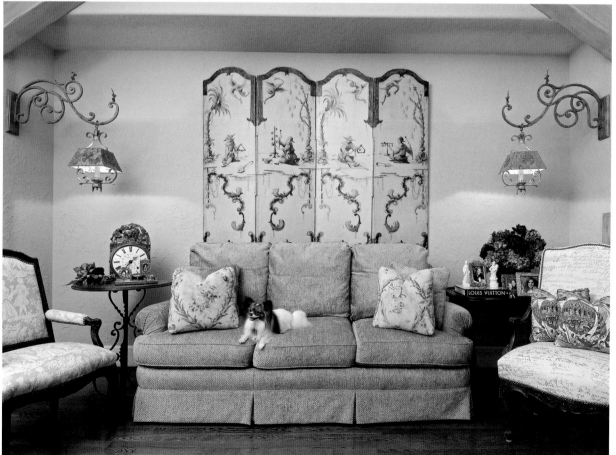

TOP
Family and friends gather around the French limestone fireplace, adorned with 18th-century Italian candlesticks and a painting of a Breton "grand pere."
Photograph by Gene Johnson

BOTTOM
Lily, a much loved Papillion, waits for someone to join her beneath the antique, four-panel, chinoiseire canvas screen.
Photograph by Gene Johnson

FACING PAGE
A treasured terra cotta bust of Frances' symbol of the Republic, The Marianne, grandly observes the living room.
Photograph by Gene Johnson

elegant, simple and quiet. Many clients have requested a similar "understated elegance," though the results are always distinctive based on their needs and preferences.

Besides creating an individual look and utilizing clients' favorite possessions, Hari Lu always strives to balance beauty and practicality. "Good design and value go hand in hand. A room must operate well for its owners and make a visually pleasing statement," she explains.

To help decorate her clients' homes and fill her shops, she travels to France twice yearly, heading both to Paris and to the South where she loves to procure antiques, accessories, and architectural elements from regional dealers' fairs. Her goal is to find the most perfect piece to fit each space. For clients who recently remodeled a master bathroom and closet, she found pair of old iron gates, which she had refinished and retrofitted to serve as a divider between the bathroom and dressing room. Other treasures become lamps, bookcase accents or focal accessories.

The highest compliment received, she says, is when clients refer her to their friends or family or when they call her back for repeat work.

More about Hari Lu...

TELL US ABOUT HOW YOUR INTEREST IN FRENCH DESIGN HAS CARRIED OVER INTO OTHER PARTS OF YOUR LIFE?

It has sparked an interest in studying the language, traveling to France, and exploring the multitude of museums I encounter on my buying trips.

WHAT DO YOU DO FOR FUN?

Cook and entertain. My husband and I, along with seven friends, have had a monthly dinner group for 20 years. I also enjoy reading. And I love to travel, especially to the mountains of Colorado and hills of the Ozarks, my childhood home.

ANYTHING YOU'D LIKE TO MENTION ABOUT YOURSELF OR YOUR BUSINESS?

My philosophy toward design. When a new client calls for an appointment, I ask them to bring along pictures or photos of rooms, furniture, or art they like. We look at them together, talk about a budget, and any practicalities. I try to incorporate the colors, styles, and furnishings that reflect their interests, tastes, and history into their design plan.

EMBELLISHMENTS INTERIORS
Hari Lu Ames, Allied Member ASID
1345 East 15th Street
Tulsa, OK 74120
918.585.8688

Windsor Market
6808 South Memorial
Tulsa, OK 74133

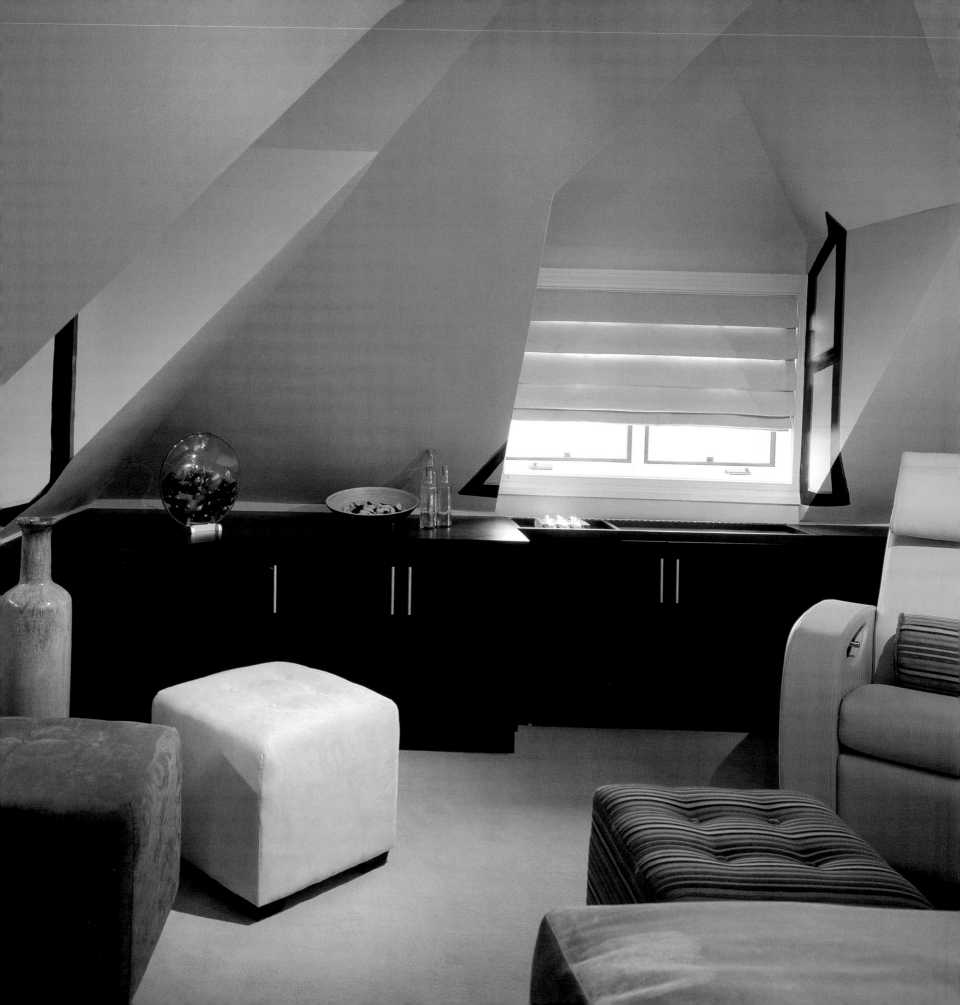

LEAH A. BAUER

Morgan/Bauer Design Group LLC

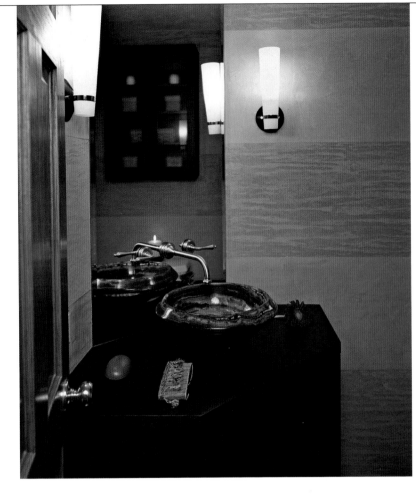

Living and working in San Francisco for 15 years gave Omaha, Nebraska native Leah A. Bauer a chance to train with a large commercial design firm. She learned about the advantages of contract materials and finishes and to manage large, complicated projects for clients like the County of Alameda, City of San Francisco and Genentech. She also learned about the skills needed to work in teams with architects, contractors, and clients, while directing the work of 18 other designers and five project managers.

Returning to the Midwest three years ago, she opened an office with business partner, P.J. Morgan, whose focus is commercial real estate. Leah decided to make her area of expertise residential design, while still working on high-profile commercial jobs. To be successful, she's broadened her skill set and style of working. "My business now is much more relationship oriented. We often do business with just a referral and a handshake," she says.

Her work remains just as challenging and creative, however, and it reveals the advantages of having worked in a different milieu. She continues to incorporate many commercial products, materials and furnishings, particularly when designing rooms for busy, active families. She also keeps exposing her more traditional Midwestern clientele to the contemporary design elements, colors, and furnishings she was introduced to on the West Coast.

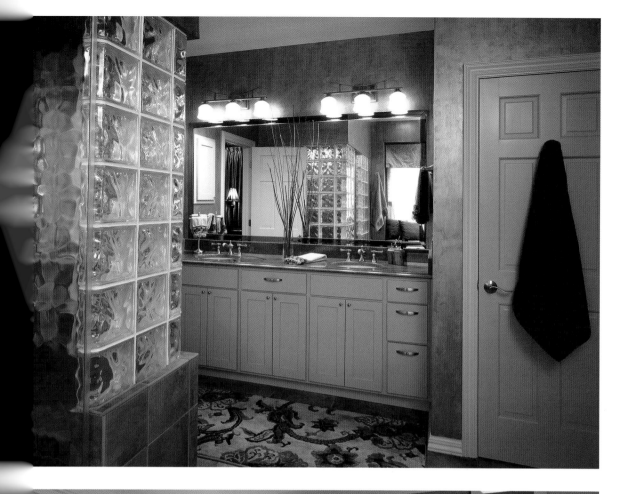

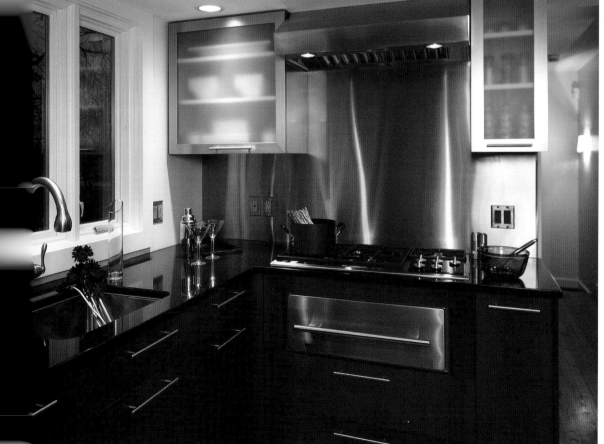

To continue to broaden her exposure to new stylistic trends, she regularly visits showrooms in Chicago and uses her favorite resources from the San Francisco Bay area. She welcomes representatives from many different design companies into her Omaha office.

Her biggest inspiration remains her clients' own preferences and needs, and she works hard to find out exactly what they are. "I do a lot of observing, ask a lot about their lives, look and see how they use their space when I visit their homes, observe their personal style, and rely on my own reactions," she says. She may also take clients to see projects she's completed for others to further discern their tastes.

In recent years, Leah has begun working on projects outside Omaha in Arizona, New Jersey, and Chicago, and she looks forward to more assignments beyond the Heartland to test and expand her design possibilities even more. "I want every project to look different, so people don't go into a house, and say, 'oh, this looks like Leah Bauer must have done it,'" she says. Her own home shows the diversity of her talents. While she says the color white best describes her because it's crisp, simple, and confident, her own dining room is a daring red.

TOP
This completely remodeled master bathroom features a custom vanity cabinet with granite tops and upgraded sinks, faucets, and lighting. The steam shower was expanded to accommodate a bench seat and finished with a deep gold and cappuccino tile; further warmth is added to the glass-block framed shower with a copper-glazed faux paint finish.
Photograph by Kent Behrens

BOTTOM
Through clever design, "full-sized" ideas and amenities were incorporated in this small 6'-1" x 9'-7" kitchen. While double ovens and a Sub-zero refrigerator were added, the remodel stayed true to the original footprint of the floor plan.
Photograph by Kent Behrens

FACING PAGE
This monochromatic-themed dining room features a variety of custom elements: glass top table with unique zigzag pedestals that mimic the buffet cabinet's front, draperies that provide privacy yet allow visibility, and whimsical giraffe-print chairs.
Photograph by Kent Behrens

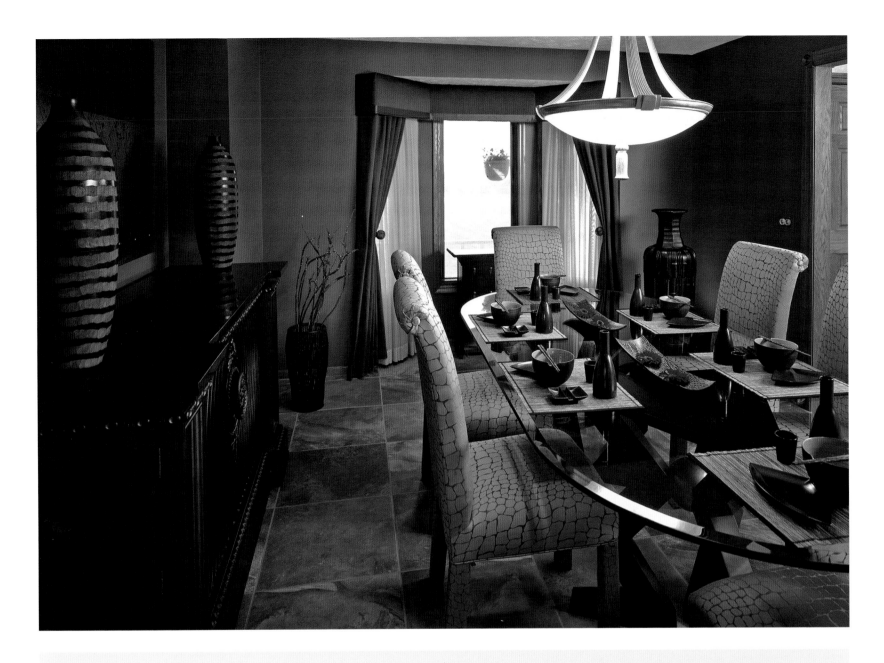

More about Leah …

WHAT SIZE IS YOUR COMPANY?

Two partners: myself and P. J. Morgan. We have four designers working with us—Julie Hockney, Julie Labens, Brenda Zier and Julie Liewer.

WHAT SEPARATES YOU FROM YOUR COMPETITION?

I have a fresh approach to interiors. I cater to each project for the client and don't have one particular style.

DESCRIBE YOUR STYLE OR DESIGN PREFERENCES.

I prefer clean lines and a strong architectural element with good proportions.

IS THERE ANYTHING YOU WOULD LIKE TO MENTION ABOUT YOURSELF OR YOUR BUSINESS?

I am a firm believer in team work, so our company is based on that. We have weekly design meetings with everyone in the office to discuss our projects, offer feedback, and we work on projects in pairs to give clients the best final product we can.

WHO HAS HAD THE BIGGEST INFLUENCE ON YOUR CAREER?

My autistic son. He sees the world from a different perspective.

MORGAN/BAUER DESIGN GROUP LLC
Leah A. Bauer
7801 Wakeley Plaza
Omaha, NE 68114
402.397.7775

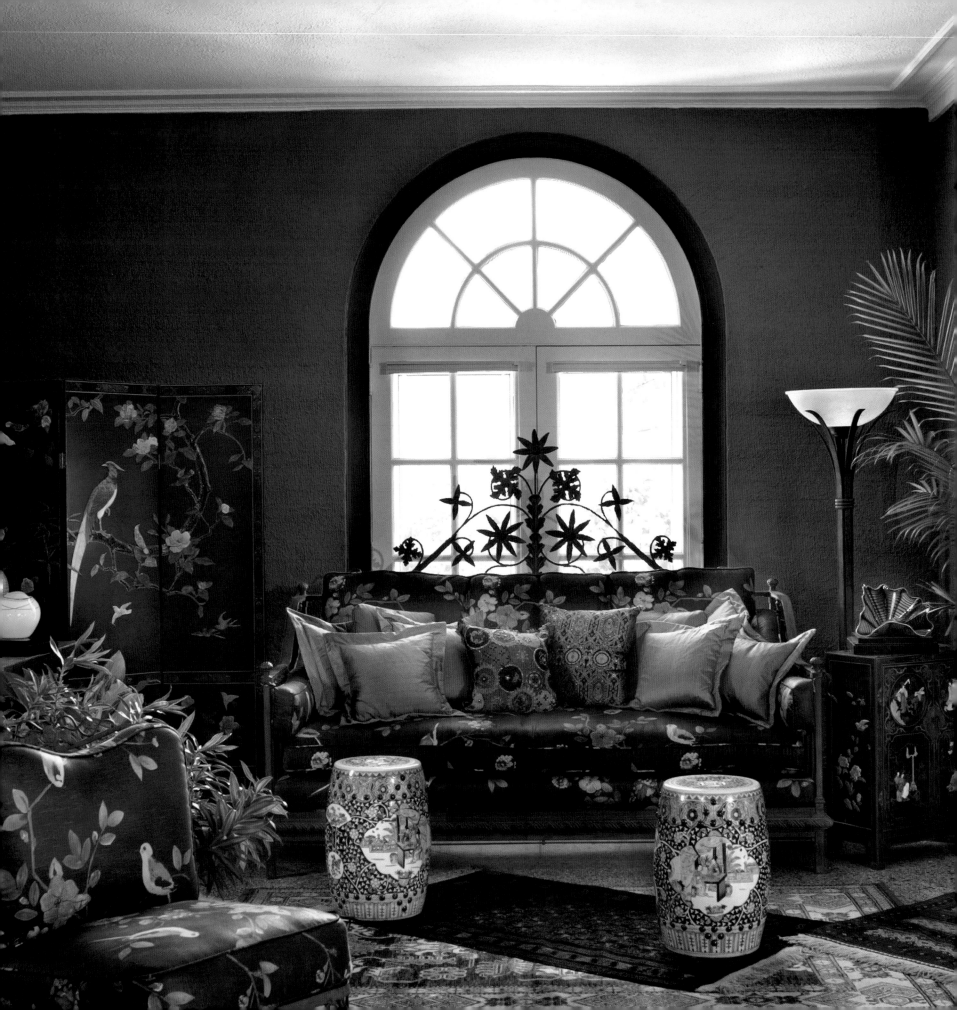

BECKY BERG

Becky Berg Design

Becky Berg loves a challenge. After surviving cancer 18 years ago, the Kansas City native asked herself: "What do I want to do with my life?" God's answer: Use your creative talent and do what you love! Becky left her career in fashion merchandising, went back to college, joined a design firm and never looked back.

A bundle of energy and enthralled with her career, Becky has assumed two new challenges. She opened her own firm two years ago, which employs four. Her husband, Jim, oversees marketing. The couple, married 39 years, are also building their dream cottage on the Oregon coast to be near family when they retire.

Colleagues and clients wonder if that day will come. "They joke about how I work all the time," she says. She may, but it's because she loves developing professional and personal relationships and fashioning décors that reflect each client's lifestyle. She attributes success to her honed listening skills and trained eye.

Her style is best characterized as traditional with a dash of the unexpected, perhaps from a vibrant color scheme or floral pattern, the latter inspired by her gardening. Becky believes that details give a room its soul.

"Challenges keep me going," Becky says. "My goal is to generate timely-produced design solutions that express the personal design style of my clients." She never shies from these experiences.

ABOVE
Home was fashioned after Mount Vernon, duplicating room colors. Parts of Robert Altman's *Kansas City* were filmed here, and the Santa Fe Trail went through the yard.
Photograph by Bob Greenspan

LEFT
The richly colored stucco walls and bright accents in the garden room invite homeowners and guests to experience casual elegance. A collection of Chihuly glass and Oriental object d'art on a palette of granite floor adorn the room.
Photograph by Bob Greenspan

BECKY BERG DESIGN
Becky Berg, Allied Member ASID
4512 Roanoke Parkway
Kansas City, MO 64111
816.841.0331
www.beckybergdesign.com

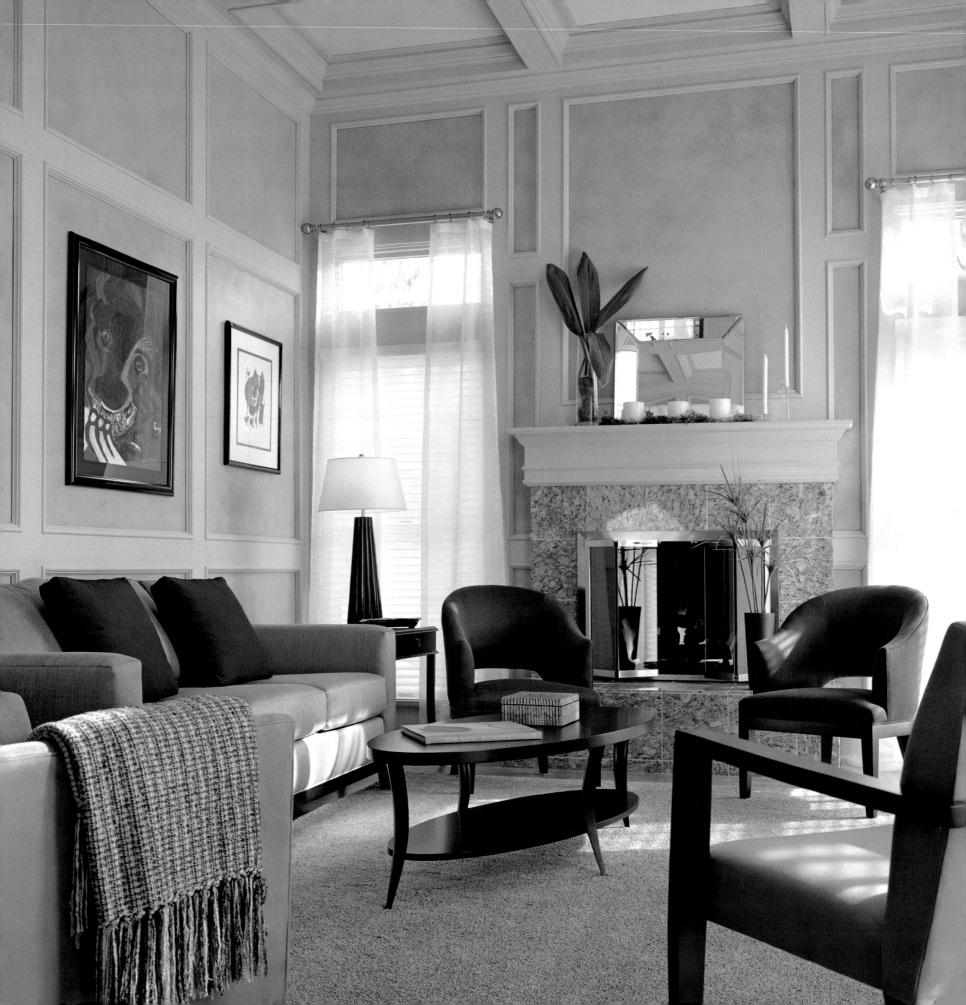

CARYN L. BURSTEIN

CLB Interiors, Inc.

At a young age, Caryn L. Burstein knew she wanted to become an interior architectural designer. She also was determined to run her own company by age 25. She met her goal a year ahead of schedule when she opened CLB Designs Inc. in 1987.

Caryn sets herself apart in her industry with her design training from college, her architectural background honed from working for a construction firm, and her ability to create a vision with the use of architectural renderings, which she mastered while attending graduate school. All these skills allow her to handle design projects from conception through completion.

Caryn set herself another challenge: to expose St. Louisans, accustomed to traditional decor, to classic contemporary styling, which she defines as timeless because of its casual elegance, streamlined forms and warm neutral tones with accents of color.

As jobs increased, Caryn recognized that St. Louis lacked quality contemporary resources. Her solution was to open a retail furniture and accessory gallery providing one-of-a-kind items along with many of her own furniture designs. The shop, CLB Interiors, focuses on custom home furnishings and accessories, while CLB Designs, Inc., offers full-service interior architectural design services for new construction as well as design and general construction for large renovation projects. In June of 2006, Caryn merged both companies under one name, CLB Interiors, Inc.

Caryn, who continues to chart the company's vision—including a second location, has gained a strong team along the way—husband Marshall, who oversees business administration and a staff of nine. The couple know they eventually may have a third partner—teenage daughter Sydney, who has exhibited a keen design eye and works occasionally at CLB Interiors, Inc.

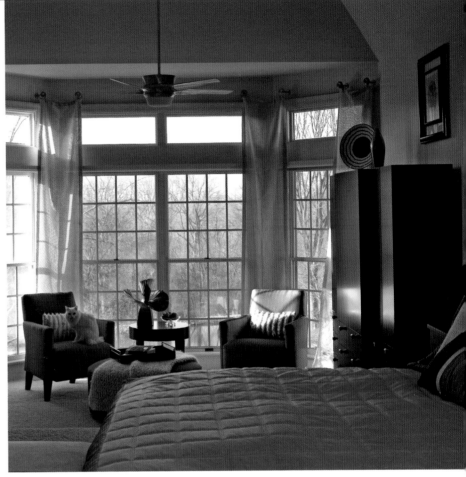

ABOVE
Peacefulness, serenity, and elegance were the inspiration enhanced by the wonderful view. Functional fabrics were kept in mind to accommodate the royal family members.
Photograph by Alise O'Brien

LEFT
Architectural detailing with neutral palette and classic elements create this sophisticated tranquil sitting room and personal home office with a custom armoire opposite the sofa.
Photograph by Alise O'Brien

CLB INTERIORS, INC.
Caryn L. Burstein
Exclusives Furniture LLC
8125 Maryland Avenue
St. Louis, MO 63105
314.721.3232
Fax 314.721.5575
www.clbinteriors.com

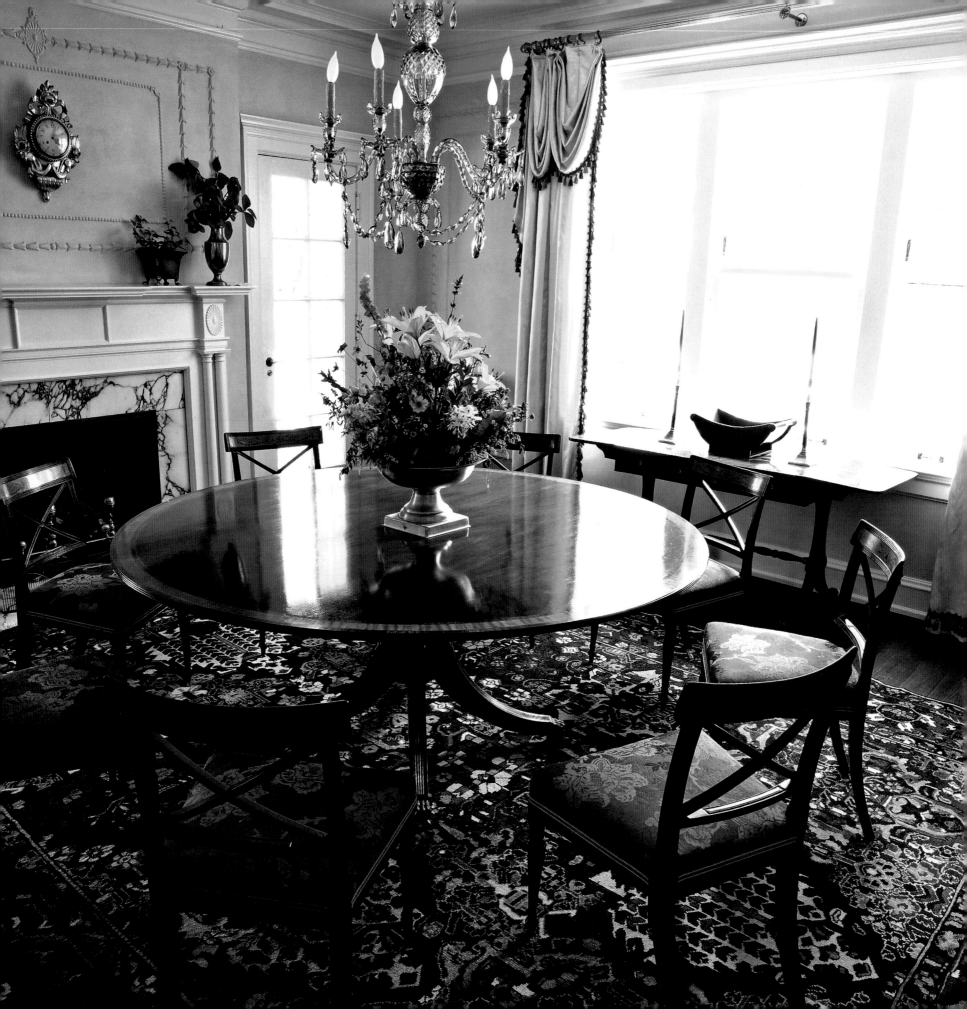

BRUCE BURSTERT

Bruce Burstert

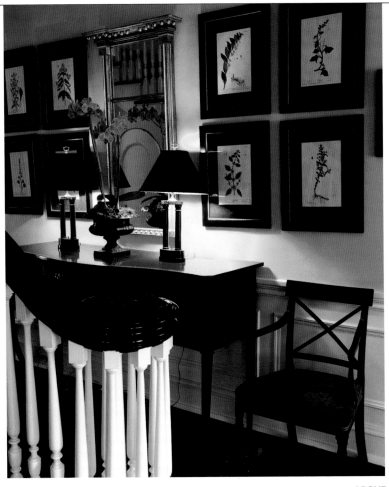

Bruce Burstert has been associated with the design and antiques business for more than 30 years. His interest in the history of decoration stems from his personal study of food, music, gardening, politics, and art. He is very interested in spaces that are appropriately designed with quality antiques, but good design prevails also in his contemporary interpretations.

The dining room (left) started with an Oriental carpet as it often does, as Bruce is most often thought of as an Oriental rug and antiques dealer. Inspiration is based on the architecture of this early 20th-century Colonial Revival house in Kansas City, MO. Featured prominently is an 18th-century Irish cut-crystal chandelier of the highest quality. The fabrics, furnishings, and paint in this room are all designs that would be appropriate for a room from this time period or before and after the dates of the house; restraint in the design prevails.

The bright yellow walls of the entry (right) are typical of Bruce's sure-handed use of specialty paint finishes with multiple coats of glaze built up to create colors and finishes of extraordinary luminosity. The 18th-century botanical prints in Bruce's custom frames flank a very fine early 19th-century American mirror.

His greatest satisfaction is when a client turns to him and says, "This is what I've always dreamed of. We use this room constantly, and we are very happy."

BRUCE BURSTERT
Bruce Burstert
122 Southwest Boulevard
Kansas City, MO 64108
816.474.9339

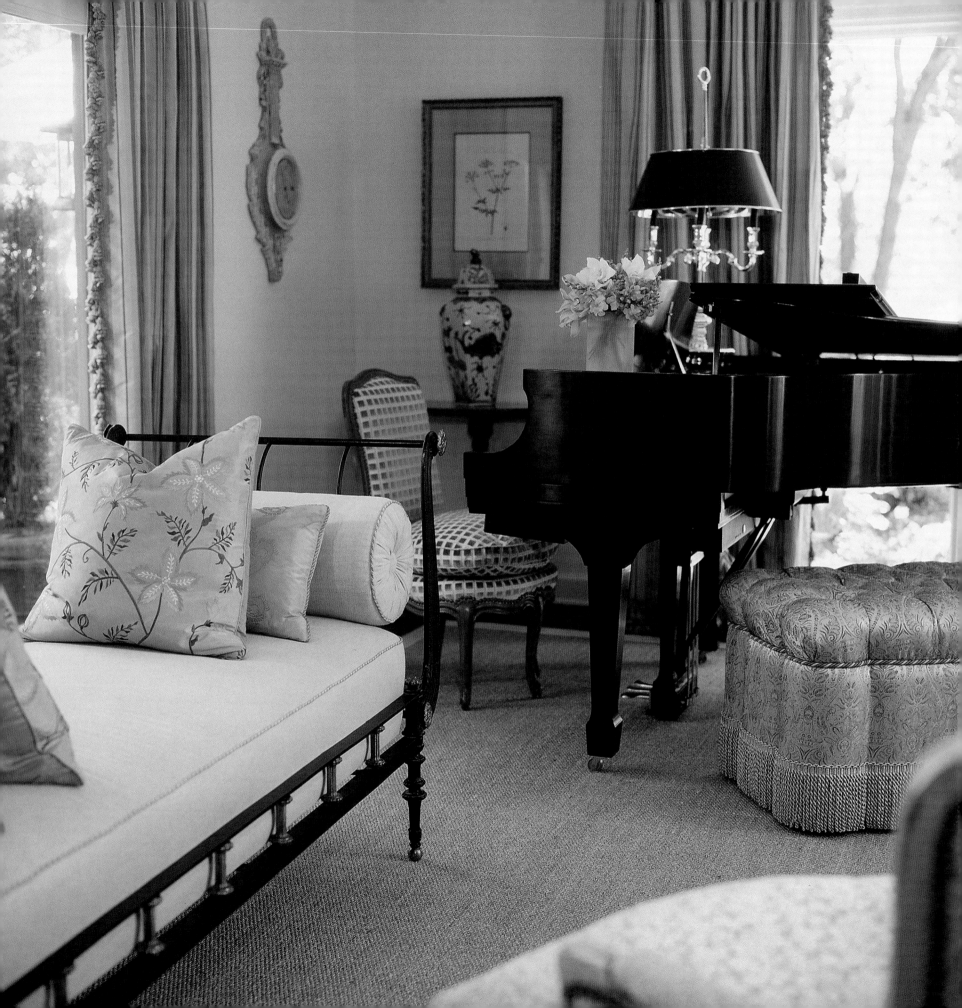

CHARLES FAUDREE

Charles Faudree, Inc.

Charles Faudree didn't know he was destined to be a designer, but he followed a natural route to that end. College as an art major, a stint at teaching junior high school, and opening a chic home accessory shop in Oklahoma City were stops along the way.

As a salesman and creative director for a Dallas decorative arts showroom, he discovered that having beautiful things in his life was essential. But, his life on the periphery would never test his creative abilities and personal ambition. So, in his late 30s, he turned his avocations into his calling. Decorating and buying antiques would never again be hobbies. Now, they were passions and always would be.

Charles' first shop and design studio were in his hometown of Muskogee, Oklahoma. His major client, as well as his sister Francie, was there. It was a wonderfully secure place to start, grow and gain confidence. But Muskogee simply wasn't big enough for his energy.

He was spending more time decorating and selling to Tulsans, the city became his new and forever home. Charles moved his shop to Utica Square in Tulsa and himself to mid-town Tulsa in 1981.

A mutual love affair started—and has continued. Charles has achieved unique prominence in Tulsa and has become a major figure in charitable fundraising from the start. But he would be the first to tell you how Tulsans have embraced him both personally and professionally, and it ended up being a great relationship both ways.

Charles' design path has taken him from English country and Billy Baldwin-inspired classy edginess, to French and Continental, both slightly more dressy than country. It is a mix that is timely and responds to his own true love of European travels. For Charles, being a designer is all about beauty, quality, color and balance in life. It was easy to write that last sentence, but making it happen in one design life is a bit more complicated.

If a significant change has occurred in recent years, it's been Charles' ability to simplify his settings and add some contemporary panache. "I used to think less is not more, but I no longer do," he says, prodded, he adds, by what he's seen on his trips to Los Angeles and by the taste

TOP
The entry of Charles' home is furnished with a simple French buffet probably from the kitchen of a château. A collection of Chinese export and transfer plates with an Italian landscape complete the wall décor. Previously published in Charles Faudree's *Country French Living*. *Photograph by Jenifer Jordan*

BOTTOM
English oak gateleg table holds the overflow of books in Faudree's library. Directoire chandelier and oil portrait of a Scottish boy moves from home to home with Charles. Previously in *Country French Living*. *Photograph by Jenifer Jordan*

FACING PAGE
Nicholas, Charles' Cavalier Spaniel, is at home in the Louis XV bergère á la reine beside an antique French mantle piece. Chinese export adds a little color to the living room. Previously in *Country French Living*. *Photograph by Jenifer Jordan*

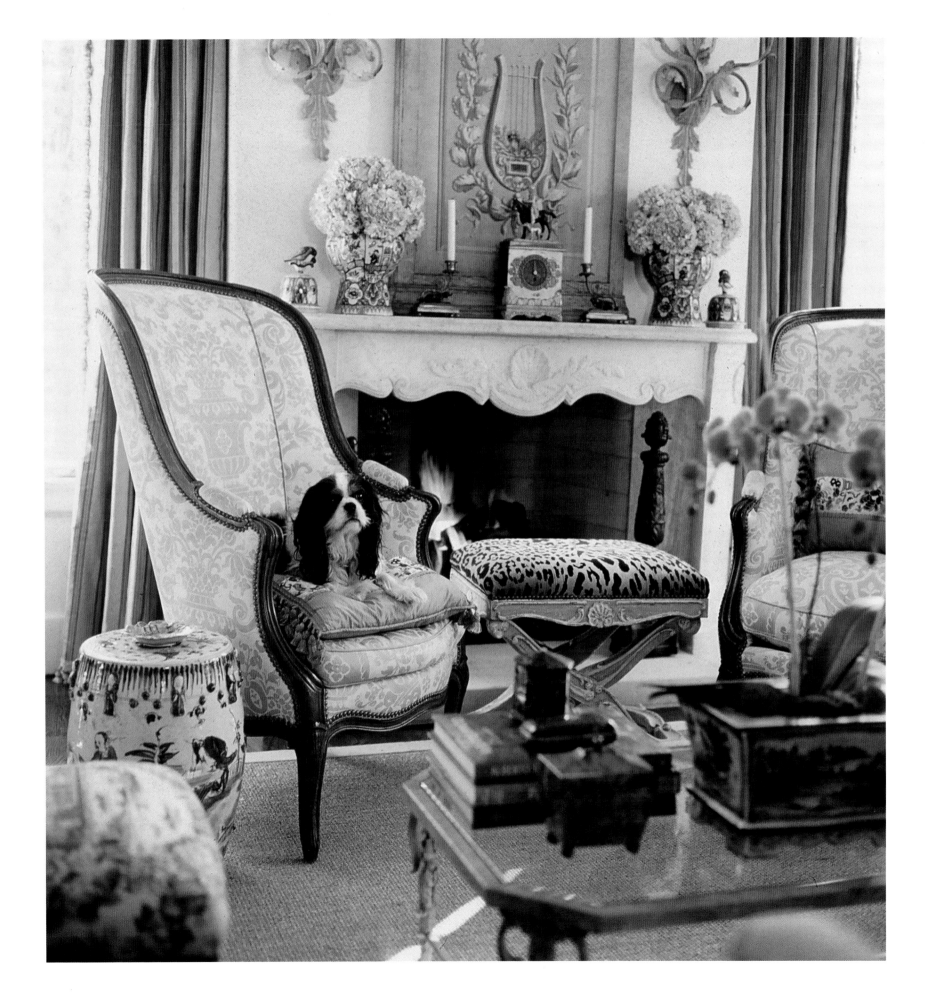

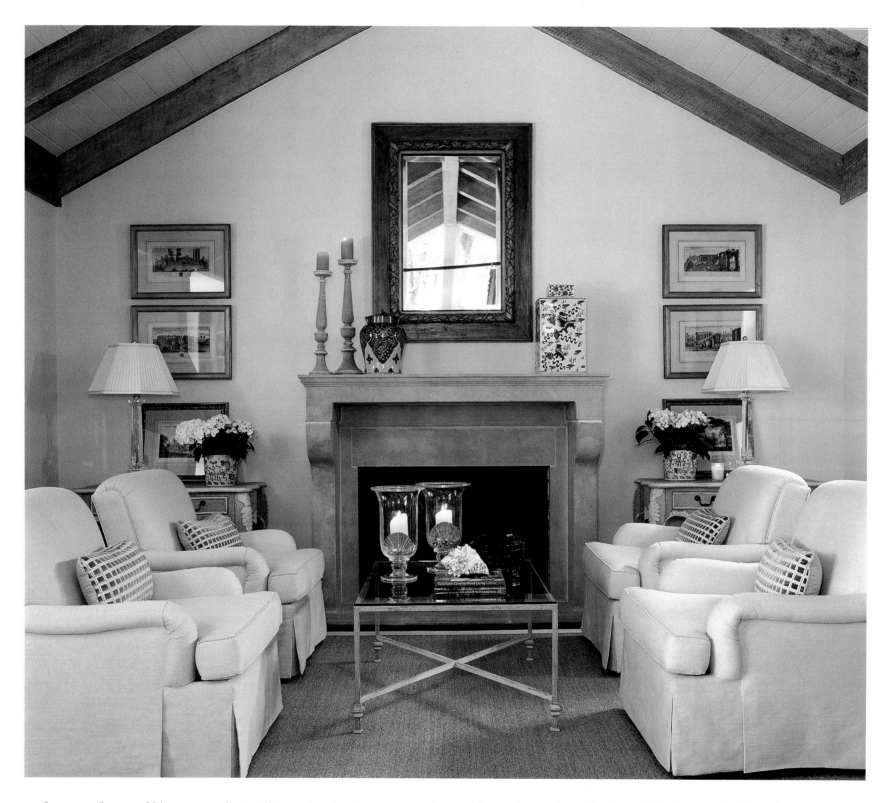

preferences of some of his younger clients. They seek a simpler, more casual lifestyle. Such change represents a welcome challenge to him, but also requires a delicate balance so that no room looks too spare and unlived in, he says.

In recent years, major projects have included a horse ranch and olive farm estate house in Seville, Spain, a divine European-style Jamaican ocean home in the Caribbean, and a classic Georgian house in Tulsa. A major re-design and decoration project at Southern Hills Country Club in Tulsa fills his always busy professional schedule. When the two country French design books that Charles published in the last three years are added in, you complete the picture of a design career in full bloom with no signs of fading.

"I'll never retire," Charles says. "I love and live for what I do." His clients and admirers add a resounding echo to those sentiments.

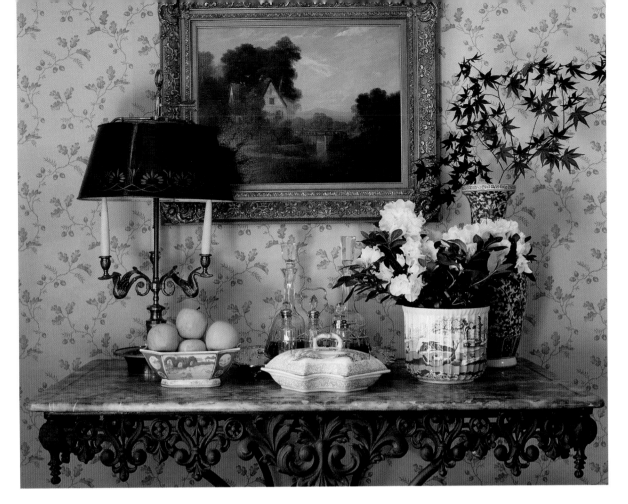

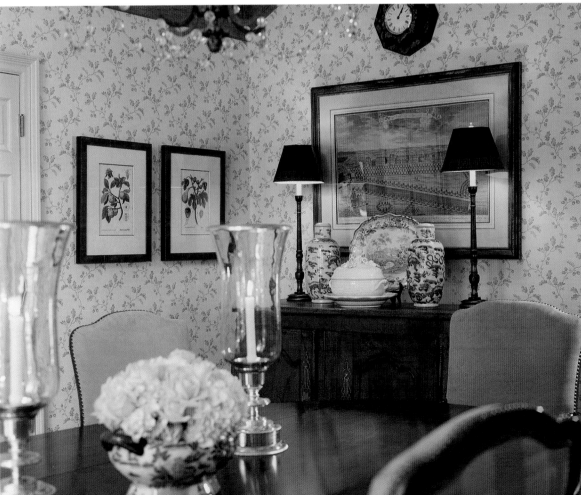

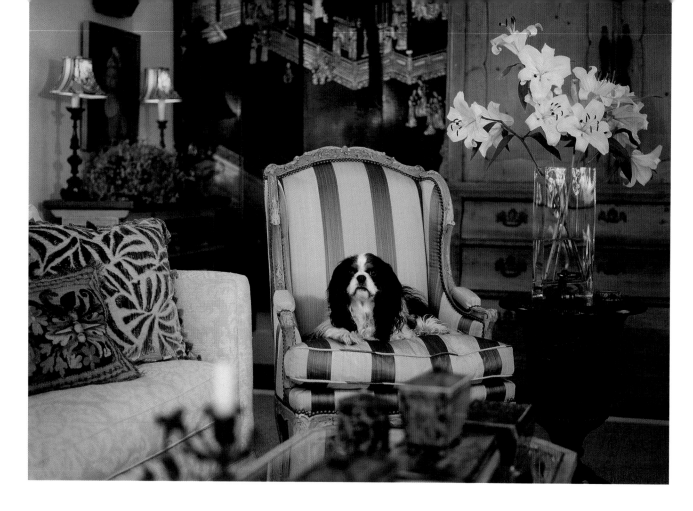

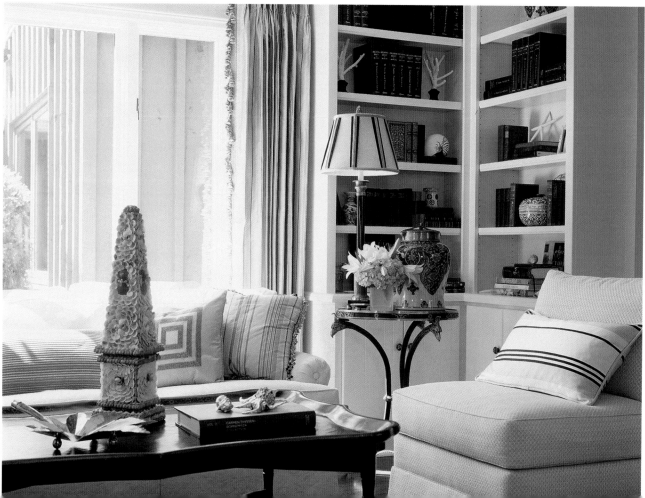

TOP
The Coromandel screen serves as a backdrop for Nicholas while he rests in his favorite bergère chair.
Photograph by Jenifer Jordan

BOTTOM
Proof that contemporary and traditional can live together is seen in the gracious living room of the Hartmans'.
Photograph by Jenifer Jordan

FACING PAGE LEFT
A reproduction French commode is flanked by a pair of Regency-style side chairs framing the vignette.
Photograph by Jenifer Jordan

FACING PAGE RIGHT
An iron and glass coffee table is accented with a black chinoiserie box and crystal hurricanes that complete the tablescape.
Photograph by Jenifer Jordan

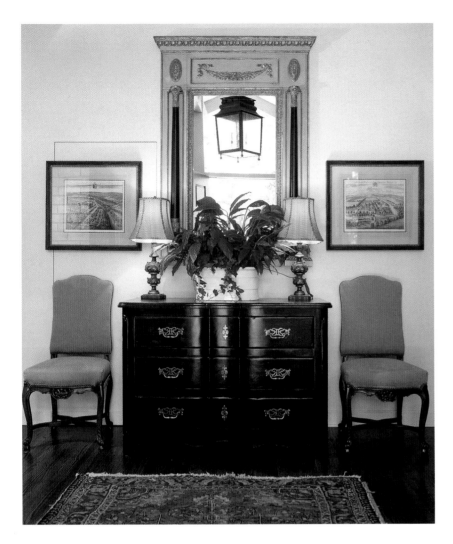

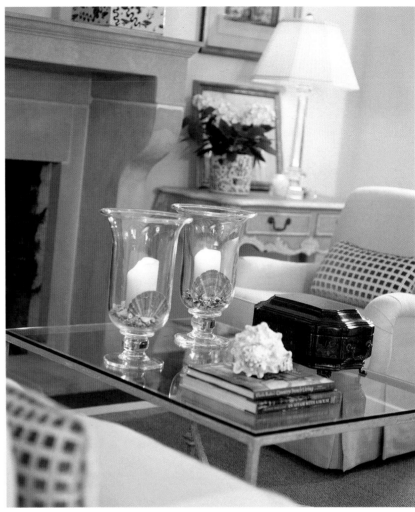

More about Charles...

WHAT PERSONAL INDULGENCE DO YOU SPEND THE MOST MONEY ON?

Travel and my dog.

NAME ONE THING MOST PEOPLE DON'T KNOW ABOUT YOU.

That I'm spiritual.

WHO HAS HAD THE BIGGEST INFLUENCE ON YOUR CAREER?

Billy Baldwin and my sister.

YOU CAN TELL I LIVE IN THIS LOCALE BECAUSE...

Of my accent.

DESCRIBE YOUR STYLE OR DESIGN PREFERENCES.

Country French with a European mix.

YOU WOULDN'T KNOW IT BUT MY FRIENDS WOULD TELL YOU I AM...

A practical joker.

WHAT BOOKS ARE YOU READING RIGHT NOW?

My Life Now by Jane Fonda.

WHAT DO YOU LIKE MOST ABOUT DOING BUSINESS IN YOUR LOCALE?

Great people, great clients.

CHARLES FAUDREE INC.
Charles Faudree
1345 East 15th Street
Tulsa, OK 74120
918.747.9706
www.charlesfaudree.com

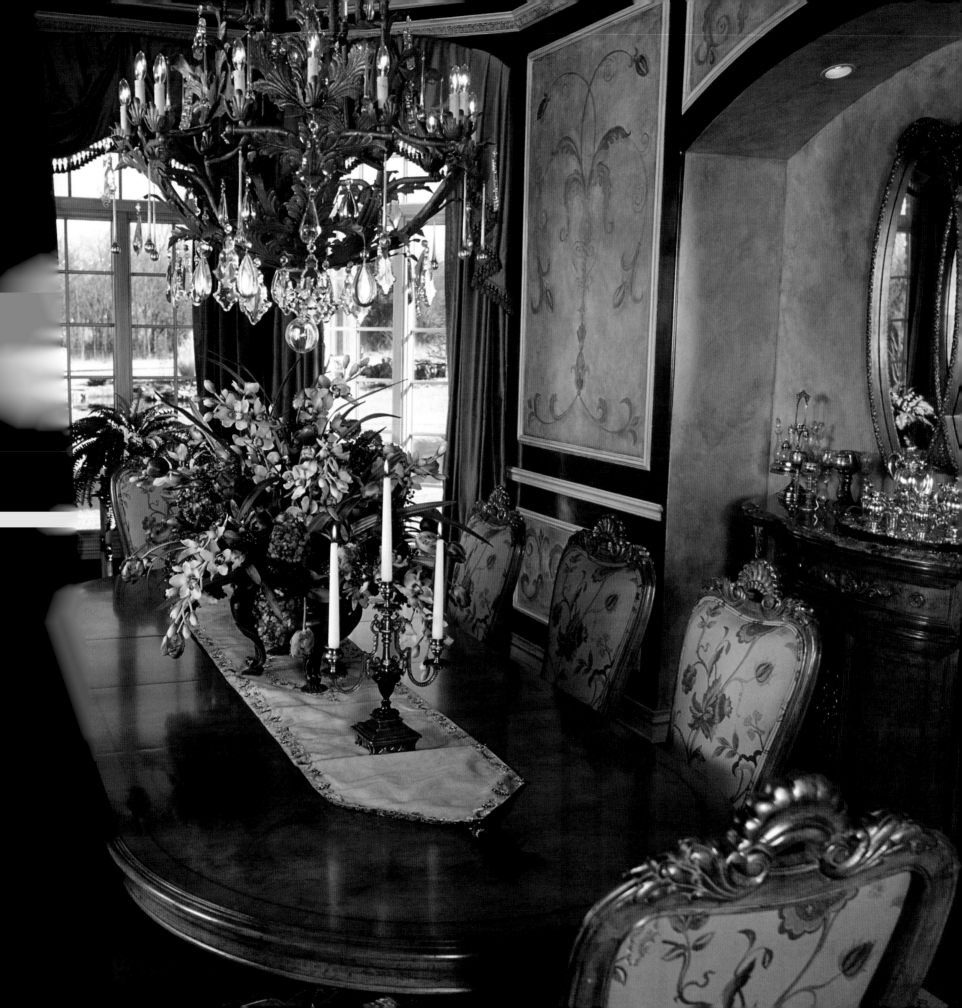

JERIS FERGUSON

Jeris Ferguson Interiors

Interior design has long been Jeris Ferguson's passion, since working with a friend in the decorating business in Colorado 29 years ago. When Jeris and her spouse moved to Springfield, Missouri, she returned to college to take drafting and design courses. Her next job with a local interior design firm helped her hone her business skills.

Jeris now operates her own business that focuses on residential design and employs one assistant. She used to manage a staff, run a retail shop and work 10 to 12 hours a day, but the desire to focus on the creative side spurred her to cut back. She credits success to understanding her clients' tastes and their Midwestern roots. "Springfield is in the Ozarks, which means it's very informal, however, a lot of my clients travel. They understand what good design is and want their homes to be beautifully decorated."

Their taste preferences are quite varied, ranging from transitional or clean-lined contemporary to Country French and Italian Tuscan. With each new client, she studies how they live, asks them how they want to use each room, whether they entertain, and what their color preferences are.

She eagerly adds her input, based on her creative spark, well-trained eye and new influences that she picks up at design markets, seminars, through travels and reading design magazines. Her biggest challenge is to find domestic resources to cut the time and problems associated with imports. Her greatest joy is working with young new clients who are her daughter's friends. "They may do only a room at a time but it's wonderful to get them started and help them avoid mistakes," she says.

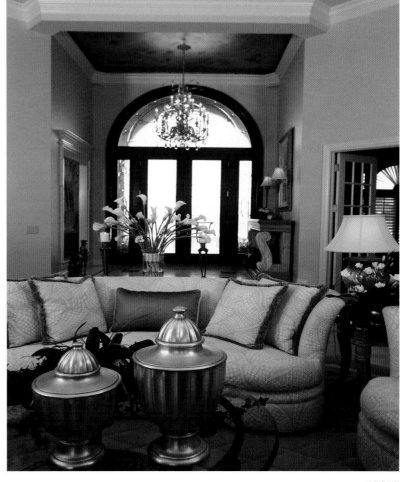

ABOVE
The entry to this Florida-inspired home is elegant and inviting. Neutrals combined with many textures creates warmth to the decor.
Photograph by Gayle Harper

LEFT
Formal dining room inspired by the clients' love for antique collectibles mixed with luxurious silk fabrics, crystal chandelier and faux-painted walls.
Photograph by Gayle Harper

JERIS FERGUSON INTERIORS
Jeris Ferguson, Allied Member ASID
1165 Post Oak Court
Springfield, MO 65809
417.889.8616

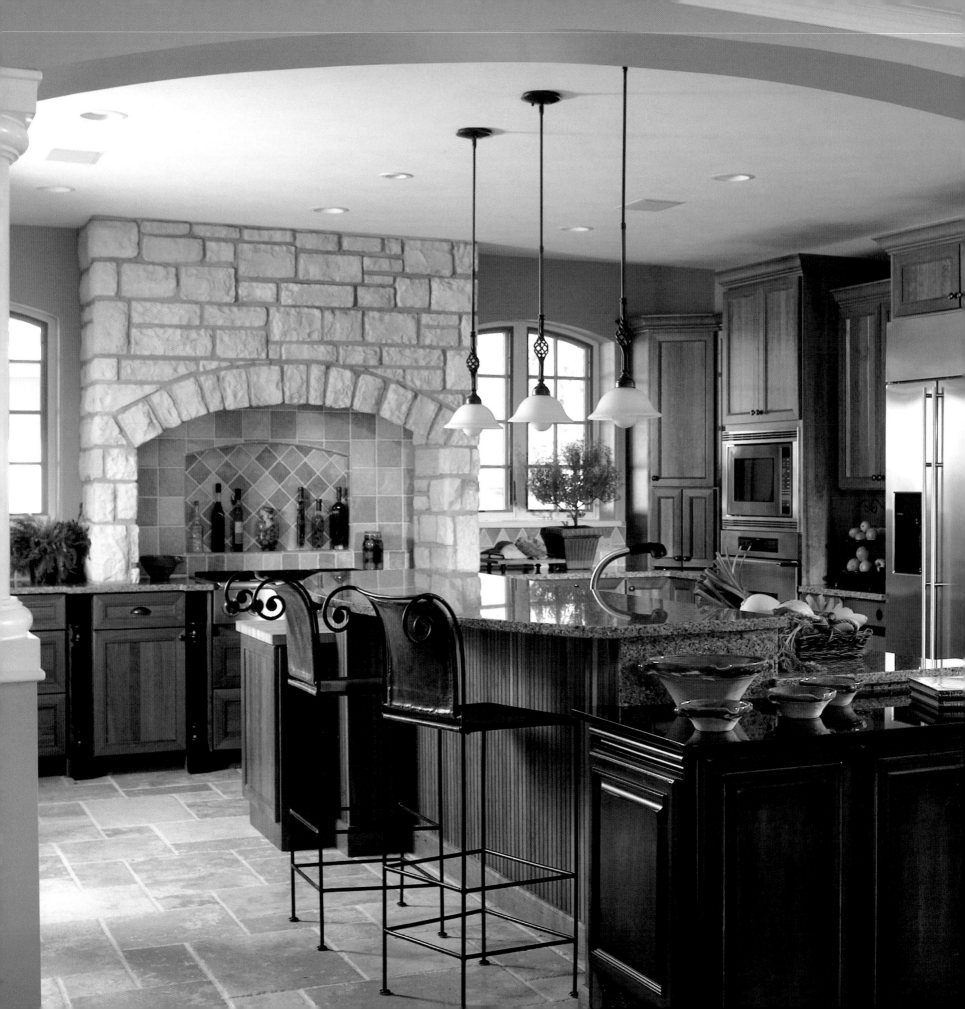

JENNIFER FISCHER

Major Designs, Inc.

Since she opened her St. Louis design firm in 1990, Jennifer Fischer has cultivated a thriving business that reaches beyond her metropolitan area. While she's happy—and qualified—to design an existing home's interior, this Indiana native has found a novel niche working on newly constructed and remodeled homes.

Jennifer never planned this specialty, yet it reflects her training and upbringing. Her mother is artistic and musical; her father, a successful businessman in real estate and construction. When she graduated from Indiana University with a fine arts degree, she worked for a firm where she oversaw its model home division. Her vision was to create interiors that reflected a variety of styles so they would appeal to a cross-section of buyers.

When Jennifer opened her firm, many of the builders and architects she had worked with—among St. Louis' premiere—sought her expertise to oversee design decisions. "We work as a team—architect, builder, designer and client. I help bring the knowledge together to get homeowners optimal results," she says.

Jennifer's work ranges from traditional to contemporary; her style reflective of her diverse clientele. From a lavish 12,000-square-foot Mediterranean home to a more intimate house that resembles a Montana lodge, Jennifer relishes having her designs look like they slowly evolved.

Frequent travels further broaden her design horizons, and she utilizes prominent home-shelter publications to stay abreast of changes. "Design can never be stagnant; it must continually evolve," she says.

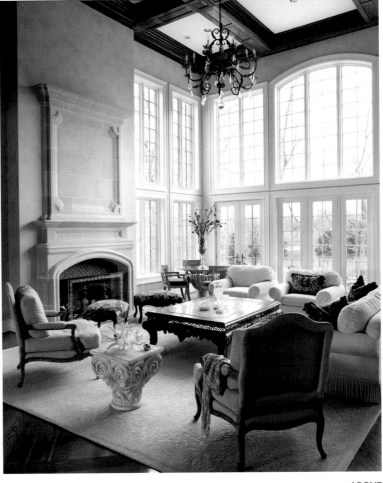

ABOVE
The sophisticated, monochromatic two-story great room features strong architectural elements such as wood beamed ceiling, carved stone fireplace and custom window-scape.
Photograph by Bob Greenspan

LEFT
This view from the hearth room shows the balance achieved by coordinating a variety of textures and finishes (granite, marble, stone, hardwood and stainless steel) to create this striking and warm kitchen.
Photograph by Bob Greenspan

MAJOR DESIGNS, INC.
Jennifer Fischer, ASID
34 North Brentwood Boulevard
Suite 203
Clayton, MO 63105
314.721.9969

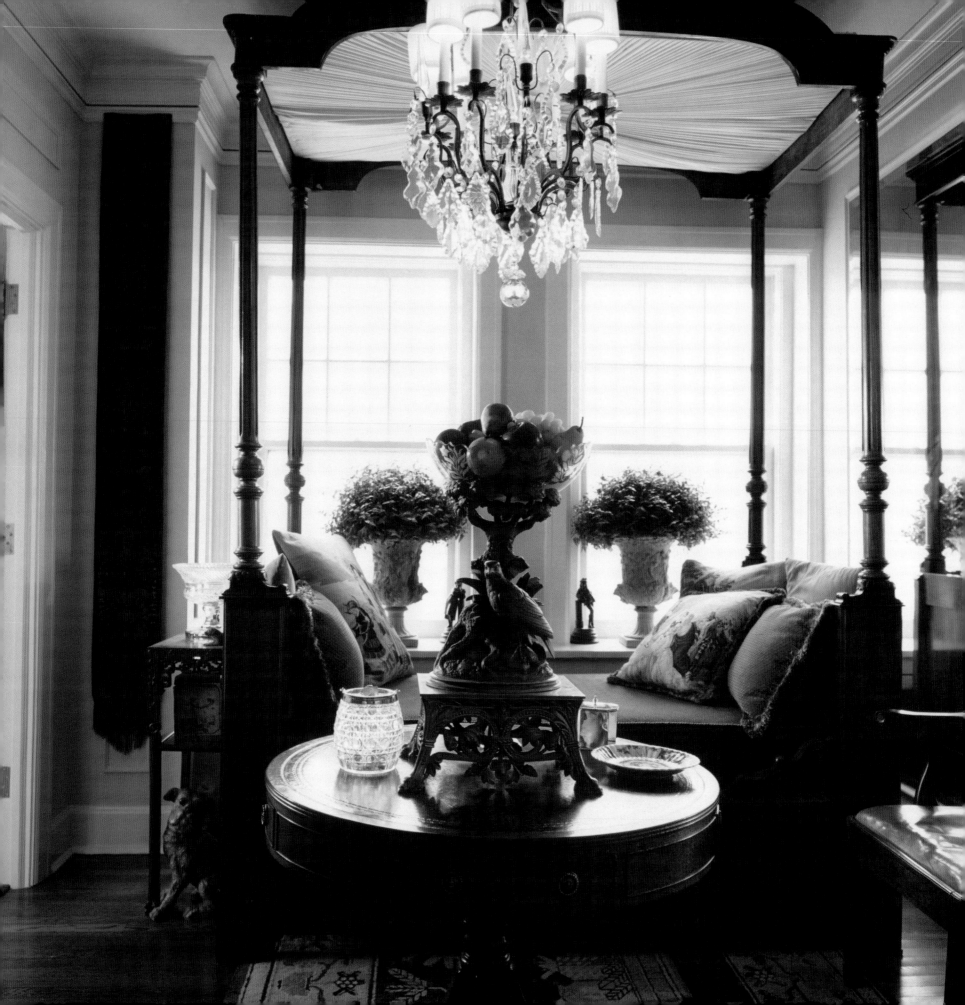

DAN FLANNERY

Superlatives

Dan Flannery enjoys creating timeless elegance with an eclectic mix of new and antique furnishings that results in a collected look.

Whether a project calls for a period or contemporary slant, he paints an environment that reflects his client's taste and also serves the needs and desires of their lifestyle.

His annual European and domestic buying trips fill the retail shop Superlatives that he founded 32 years ago. Located on the historic Country Club Plaza in Kansas City, the store also includes his design studio.

Designing an interior for clients may also involve redoing the interior architecture to accommodate modern amenities and improve the room's aesthetics and personality. Dan's trademark classic approach is always warm and inviting; fads and trends of the day are of no importance to him.

For one set of clients building a luxury oceanfront compound of five 16th-century Italian villas in Hilton Head Island, South Carolina, Dan spent three years working with a design team from conception through completion. The design challenge, which he relished, was to capture the grandeur and patina of the era yet adapt it to their casual lifestyle.

"Pleasing the clients is the main goal," he says. If he doesn't think he has a flair for their request, he recommends someone who does.

ABOVE
Chinese lacquer and William Tell toile are two components in this eclectic bedroom.
Photograph by Bill Matthews

LEFT
Antique daybed and Black Forest carving appoint this high-rise sunroom.
Photograph by Bill Matthews

SUPERLATIVES
Dan Flannery
The Country Club Plaza
320 Ward Parkway
Kansas City, MO 64112
816.561.7610

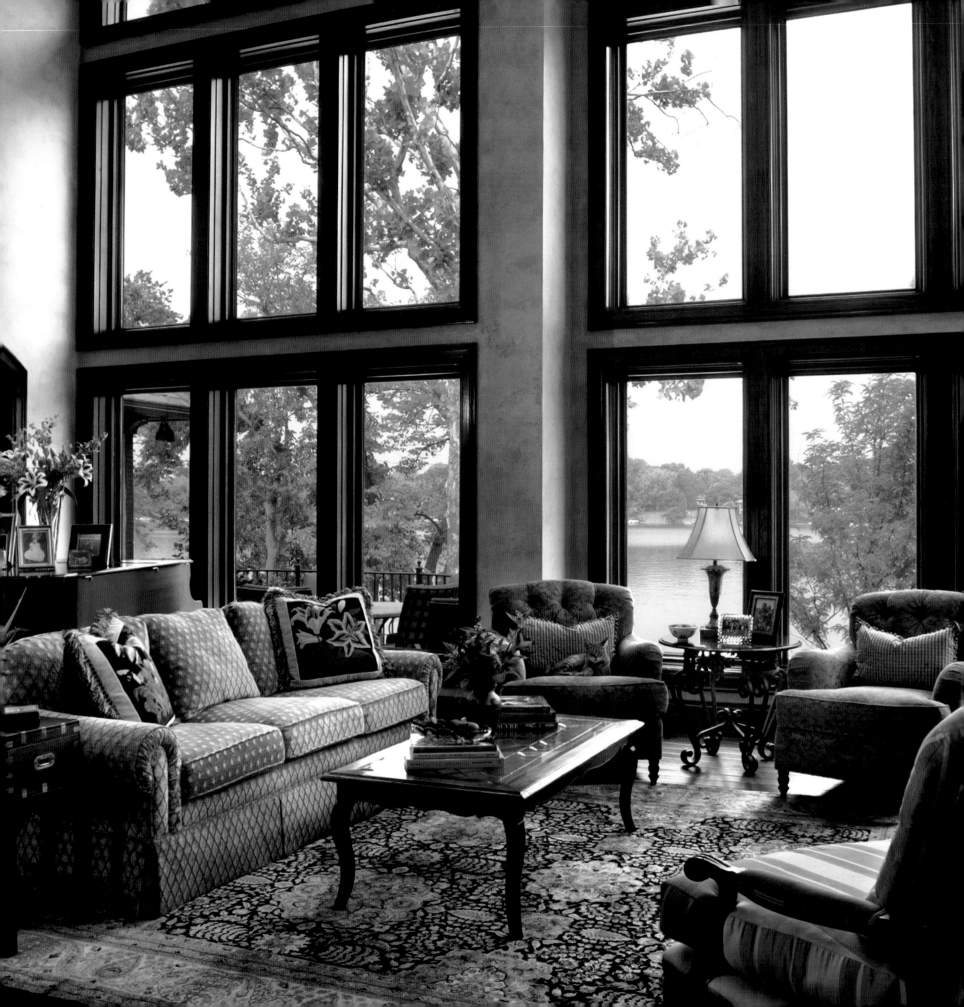

Renée Grissom

Renee Grissom Design, Inc.

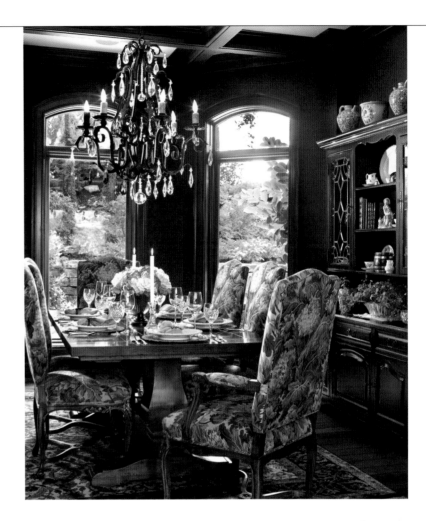

A love of nature, travel, and a fascination with many cultures has allowed Renée Grissom to provide an array of design services for her clients. Renee feels that the design process is a journey that allows clients to explore the concept of their own perfect haven.

Drawing upon her 12 years of experience with Polo, Ralph Lauren, Renée has come to appreciate classic design and the way it brings the past and present together. As an admirer of Frank Lloyd Wright, she believes that the heart of any work is simplicity, harmony, unity and integrity, all of which are reflected in the world around us. With this inspiration in mind, Renée created her own furniture line, Essential Elementes (www.essentialelementes.com), a collection of tables that reflect her love of earthy colors and clean lines.

Believing that our natural surroundings are of perfect design, Renée encourages her clients to incorporate a mixture of textures, colors, shapes and materials. This combination works in all settings from the very traditional to ultra modern.

After an initial consultation to determine a sense of direction, she continues throughout the design process to encourage her client's input as well as decision-making. "I want them to feel their home was their creation and I was merely the guide."

Renée concludes: "My ultimate goal is to create surroundings that are not only comfortable and beautiful but unique to each individual, and the design must stand the test of time. Collections of artifacts, rugs, original art, family heirlooms, books, and fresh flowers will always be in style."

ABOVE
Renée combined furnishings with Coronado, California architect Carl Buchanan, Jr. AIA, create a comfortable
yet striking setting. Dining chairs and end tables are from Essential Elementes, her own furniture line.
Photograph by Bob Greenspan

FACING PAGE LEFT
Designer's 1920's Prairie style home with a family heirloom wingback paired with a mulit finish modern end
table. *Renée* bronze sculpture by Tom Corbin. Corner cabinet is an Essential Elementes piece.
Photograph by Bob Greenspan

FACING PAGE RIGHT
This dining room contains a mixture of materials from stone and glass to bamboo. Modern host chairs
combine with an antique sideboard and Thai artifact.
Photograph by Bob Greenspan

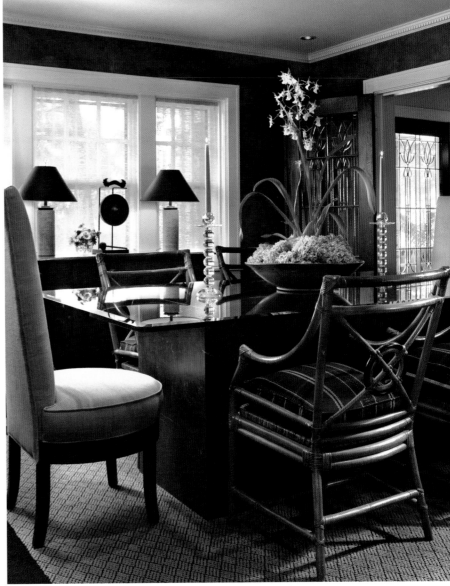

More about Renée…

HOW LONG HAVE YOU BEEN AN INTERIOR DESIGNER/
DECORATOR? HOW LONG WITH THIS COMPANY OR IN
BUSINESS?

15 years in my own business; 12 years at Polo, Ralph Lauren previously.

WHAT SIZE IS YOUR COMPANY-EMPLOYEES, PARTNERS, ETC.?

Small with two employees: office manager, Annette and design
associate, Rhiannon.

WHAT IS THE SINGLE THING YOU WOULD DO TO BRING A DULL
HOUSE TO LIFE?

Great art.

HAVE YOU BEEN PUBLISHED IN ANY NATIONAL OR REGIONAL
PUBLICATIONS?

Kansas City Star, KC Home and Garden, Spaces, and *KC Luxury Living.*

RENEE GRISSOM DESIGN INC.
Renée Grissom
2405 West 103rd Street
Leawood, KS 66206
913.383.8222
www.reneegrissomdesign.com

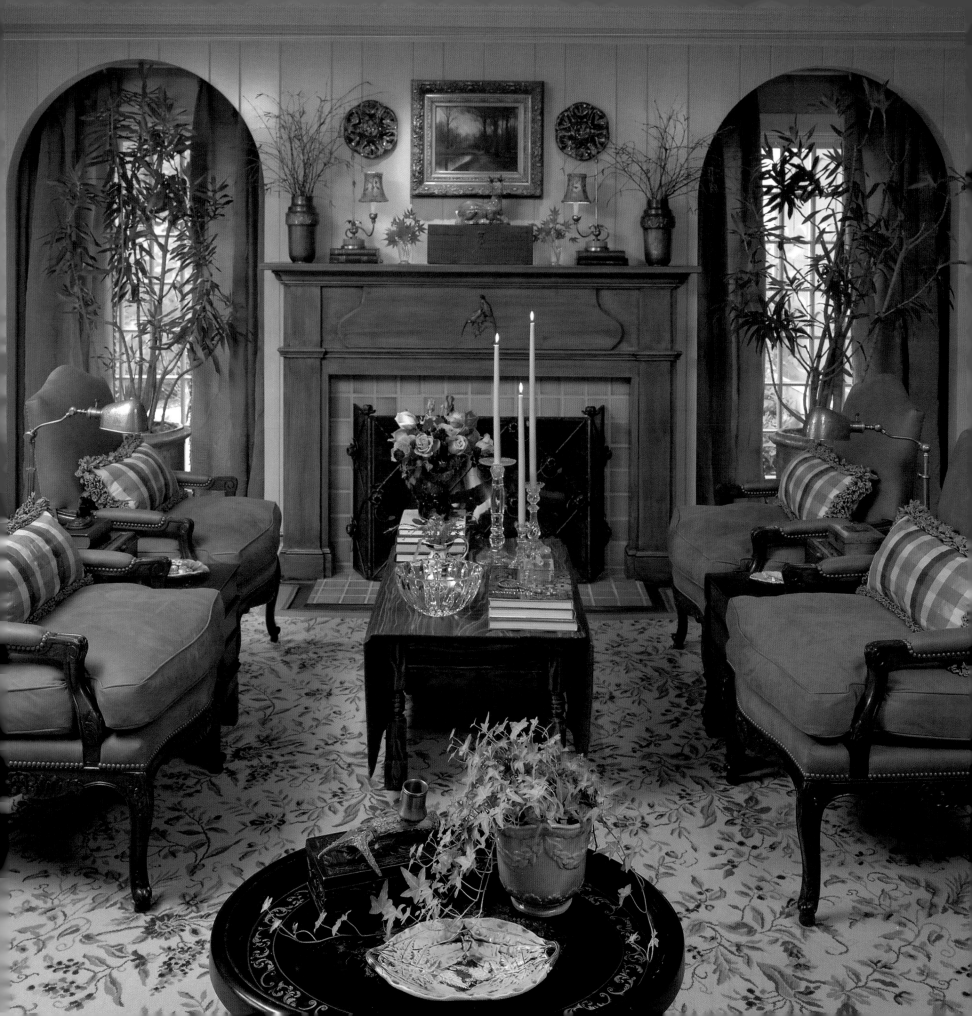

ROBERT S. CISAR, JR. & KIRK A. B. HOLT

Cisar-Holt, Inc.

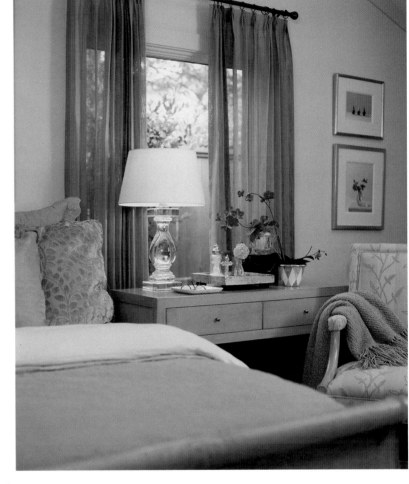

As a child, Kirk A. B. Holt was interested in architecture and interior design, and he cherished the *Architectural Digest* magazines his stepfather brought home every month in Oklahoma City. Kirk majored in design and interned while in college where he learned the advantage of taking a team approach and working with a builder, architect and landscape designer. A second job lasted just a year, but then serendipity occurred.

Kirk answered a newspaper ad for a design assistant job placed by prominent Tulsa designer Robert S. Cisar. Their work relationship thrived, and three years after he joined, Kirk was made a partner. Cisar, who was 20 years older, taught Kirk about more than decorating. He had previously purchased and renovated homes, then started interior home painting, then paper hanging, then home remodeling before realizing that he had a gift for interior design. The men opened a retail showroom to have enough furnishings and accessories to offer their clients as well as other area designers' homeowners. Soon they were not only working on jobs in Tulsa but also in London, Jackson Hole, Chicago, Kansas City, Phoenix, the Eastern shore of Maryland, and Watch Hill, Rhode Island.

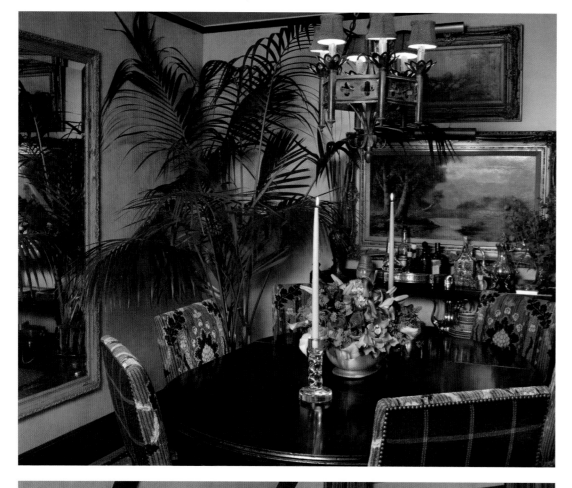

Their design style also evolved. While many of their Heartland homeowners seek classic timeless décor, more in Tulsa and beyond ask for contemporary design. "They come in and want cleaner lines, less clutter. They ask us to get rid of the extra stuff," says Kirk. But the mantra of Cisar-Holt has always been not to forge a signature look but to design for a client's personality and needs while respecting the architecture of the residence. One homeowner with a huge Majolica collection and accessories wanted her rooms to be filled to the rim with all her "stuff," Kirk says. Another wanted to enjoy long conversations over dinner so there are lounge chairs rather than traditional seating, he explains. Kirk's own home, an English Tudor, is filled with mostly traditional furnishings, accessories, and paintings.

The firm weathered a tremendous blow in March 2006 when Robert died three months after being diagnosed with cancer. He and Kirk had always done the interviewing, measuring, and designing together, Kirk says. "I started off being his assistant and knowing to keep my mouth shut during appointments, but we went back to the office and discussed everything," he recalls fondly. "He was creative and had this wonderful

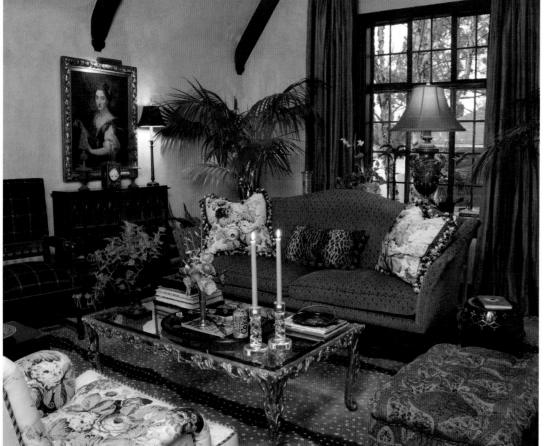

TOP
In the small dining room of their personal residence, Kirk and Robert added dimension by hanging a 4' x 6' mirror opposite the outside window wall. Circa 19th century chairs are reupholstered in figured velvet from France and contrasted by the vintage contemporary styled Steuben crystal candlesticks. Vintage oil paintings are complemented by the large Kentia palm.
Photograph by Michelle Weeks

BOTTOM
The varnish glazed plaster walls in their renovated 1930's English Tudor cottage add depth to the living room. Luxurious fabrics from the silk draperies to the figured velvet sofa fabric are complemented by the gold leaf twig and glass coffee table and contrasted with the leopard area rug to make an inviting space to entertain and visit. The floral cotton chintz on the custom lounge chairs adds color to the room.
Photograph by Michelle Weeks

FACING PAGE
Open to conversation was the motive for this dining room. This remodeled space now opens to the gourmet kitchen and is conducive to lively discussions with the chef and guests. Again the luxurious dining chair fabric complements the clients' art collection.
Photograph by Jenifer Jordan

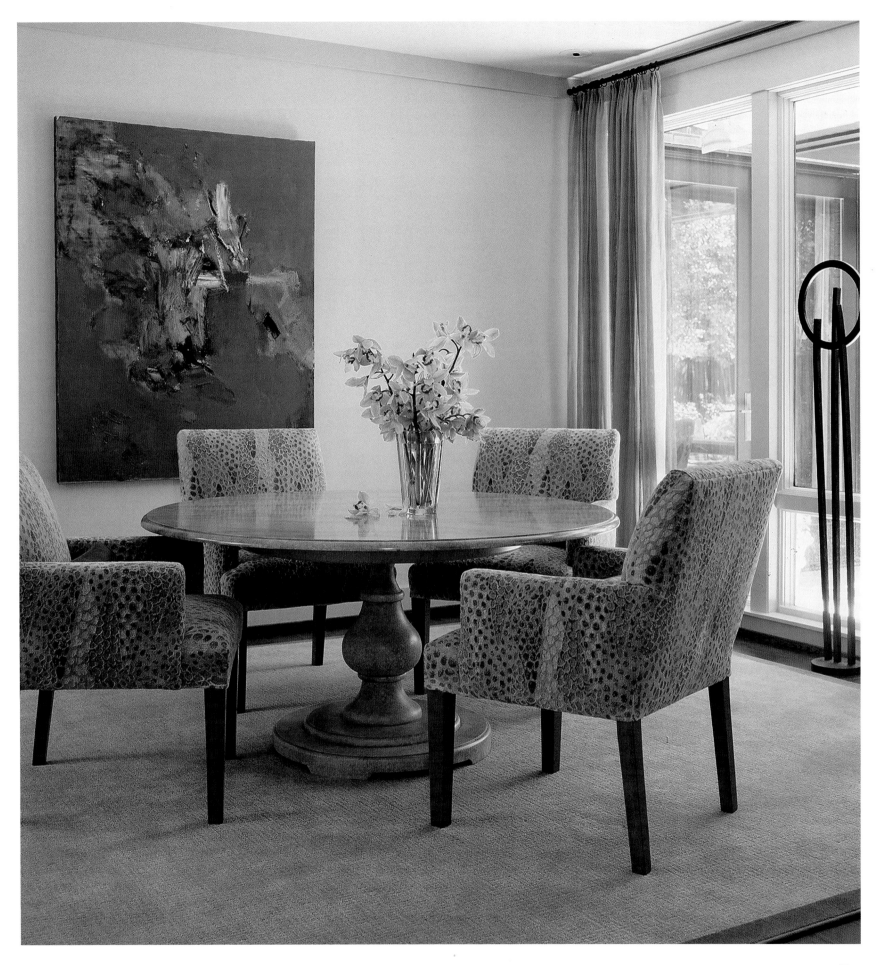

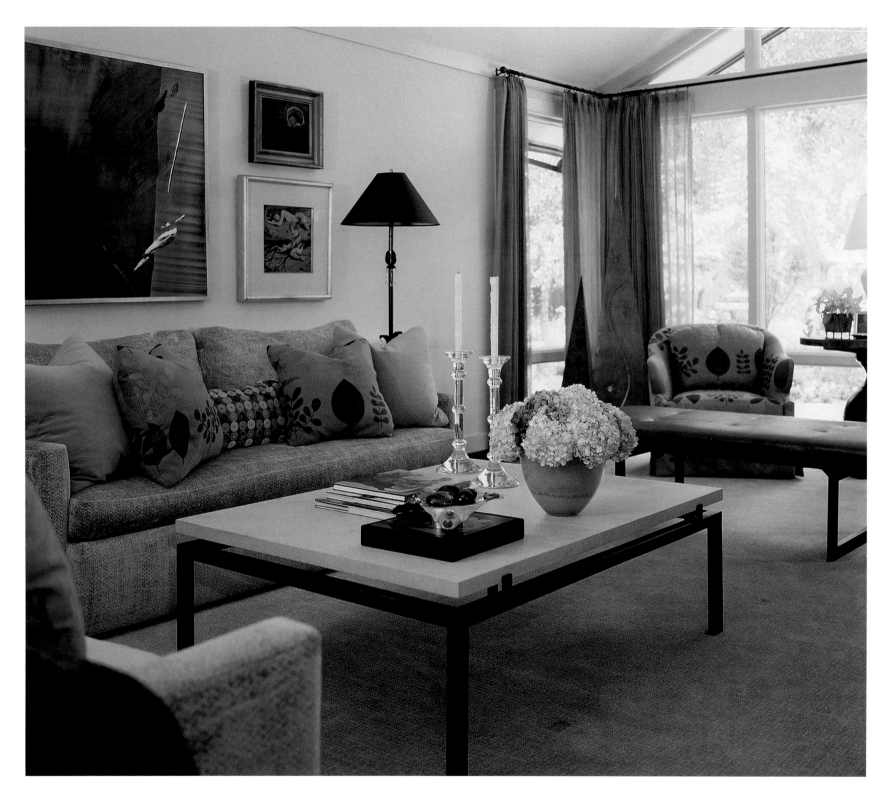

ability to retain the vision of what the project should be like until it was done. I understood design but was also the numbers person," he says.

The firm continues to carry on with Jay Exon running the showroom and handling displays and sales, Monica King overseeing all projects as project manager, and Susan Blair as the bookkeeper. "There isn't any change. We'll keep doing high-end residential projects and developing unique creative

lifestyles for unique individual clients," Kirk says. Most importantly he and the others continue to look ahead.

Kirk will complete the London-style townhouse that he and Robert started to build in a downtown neighborhood. "We wanted to experience building our own house after remodeling," he explains. They found a spectacular site on the Arkansas River close to parks and restaurants. "We were going to pioneer

a little bit but it's a wonderful, charming, older neighborhood." Kirk also hopes to do design work for a celebrity or two some day. Does he have anyone in mind? "Yes," he answers quickly—"wife No. 1 (Jeanne Tripplehorn) on the TV show, *Big Love*, who's from Tulsa but lives in California and is said to want to return." And he knows that Robert will guide him. "He was the most supportive person I'd ever met of me and of others. If someone wanted to start a new business, he'd share his ideas and vision, and he was usually right. He will be greatly missed." Those who know Kirk know he and Cisar-Holt will carry on splendidly.

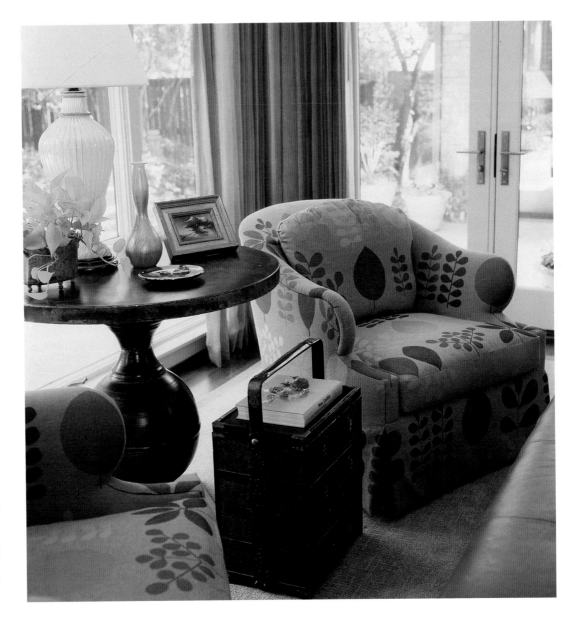

RIGHT
An oxidized zinc table is flanked by custom swivel lounge chairs designed to take advantage of the interior and exterior living spaces. A vintage Venetian glass lamp anchors the table.
Photograph by Jenifer Jordan

BELOW
Left, Robert Cisar, Jr. and right, Kirk Holt.
Renée Photograph courtesy of Oklahoma Magazine/ Schuman Publishing

FACING PAGE
Custom furnishings of rich textures and patterns complement the clients' extensive art collection. When fully pulled for subtle privacy, the sheer linen draperies still allow appreciation of the beautifully landscaped side yard that over looks a city lake.
Photograph by Jenifer Jordan

More about Kirk …

NAME ONE THING MOST PEOPLE DON'T KNOW ABOUT YOU.

They think I'm serious, but I have a lighter side they don't see.

WHAT COLOR BEST DESCRIBES YOU?

Green because I'm always growing.

WHAT ONE ELEMENT OR STYLE STILL WORKS FOR YOU?

Classic lines.

DESCRIBE YOUR STYLE OR DESIGN PREFERENCES.

Luxurious fabrics, comfortable yet elegant décor.

ANY HOBBIES?

Yes, yoga, but I work so much, so I have to try to schedule it in. I love to travel and booked a cruise to the Baltic next summer. I can't go now because I'm busy with work and building a house!

CISAR-HOLT, INC.
Robert S. Cisar, Jr.
Kirk A. B. Holt, ASID
1607 East 15th Street
Tulsa, OK 74120
918.582.3080

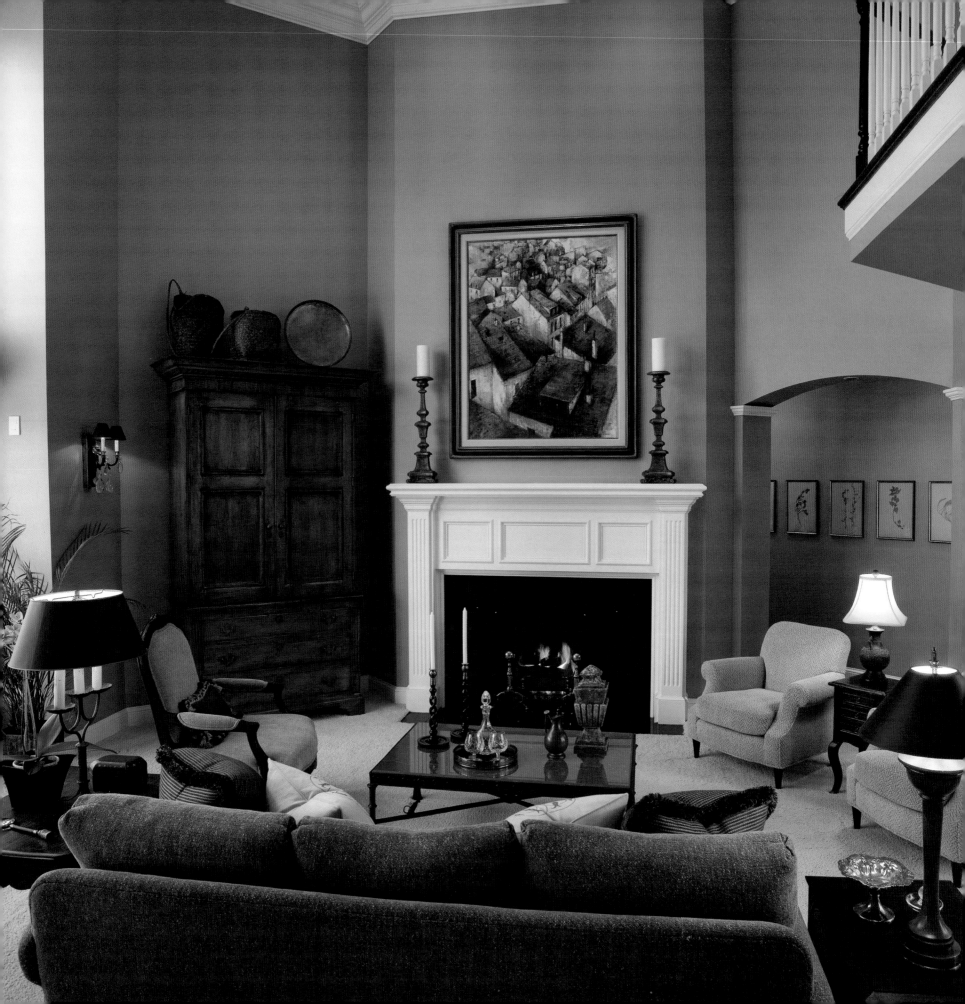

DANI JAMES

Crossroads Interiors

Dani James never expected to be an interior designer. A Kansas City native, Dani went to Vassar College in Poughkeepsie, New York, where she majored in philosophy and theology. After graduation, she returned to the Heartland and worked in the securities, computer and real estate industries.

She segued into decorating after being asked to design the common areas of several condominiums. She discovered her passion for the process, tapping into her creativity, producing a quality result and developing personal relationships. Clients became close friends and once many of their children were grown they became her second generation of homeowners.

Whether the project is residential or commercial, Dani works with clients, collaboratively. She carefully listens to likes and dislikes. "I want to bring out their personal style and help them explore the ways in which they use their space," she says. She also wants to incorporate applicable principles of Universal Design to help them overcome future challenges.

Dani believes in exposing clients to what they may not know about and what she loves. In a recent dining room project, she installed a limestone wainscoting and upholstered the walls above in luxe cashmere. The mix of textures was completed with a subtle balance of art, antiques and lighting from different periods.

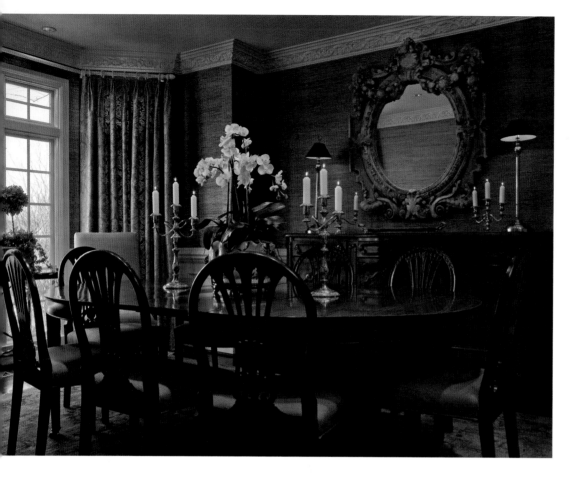

Her own exposure comes from traveling. "I've loved going through old stone castles and antiquing. Such experiences may not translate directly into my work, but they seep in and influence what I do," she says.

The designs she produces reflect a "layering" approach. She starts with the outer shell or horizontal and vertical background surfaces, which she often keeps neutral. She adds patterns and designs in furniture, fabrics, accessories and art. "Each builds upon the previous stage," she says, "to produce a balanced composition."

Dani is a student of design and enjoys reading about the history of design. One of the designers she most admires is John Saladino. She admires his restrained elegance and frequent historical references. She just completed designer Rose Tarlow's book, *The Private House,* and identified a kindred soul.

What Dani believes she still does best relates to the human component. She believes that an inspired collaboration between designer and client will result in a uniquely fulfilling and personal realization for both. "I've never lost a client. We form life-sustaining relationships."

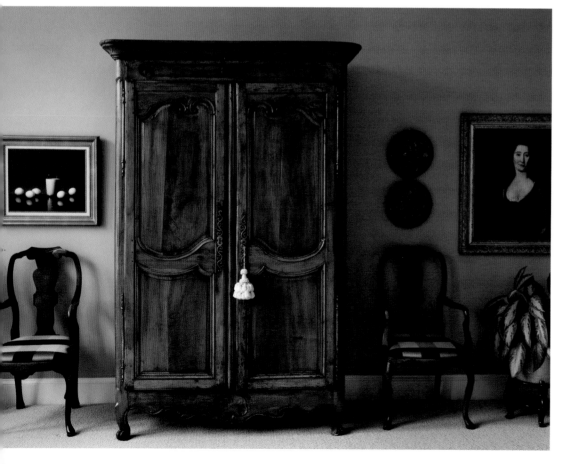

TOP
A glowing dining room with a distinctly French flair.
Photograph by Blaine Fisher Photography

BOTTOM
This 18th-century French walnut armoire sets the stage.
Photograph by Blaine Fisher Photography

FACING PAGE
A cozy music room nook sports a cashmere throw in a Larsen fabric.
Photograph by Blaine Fisher Photography

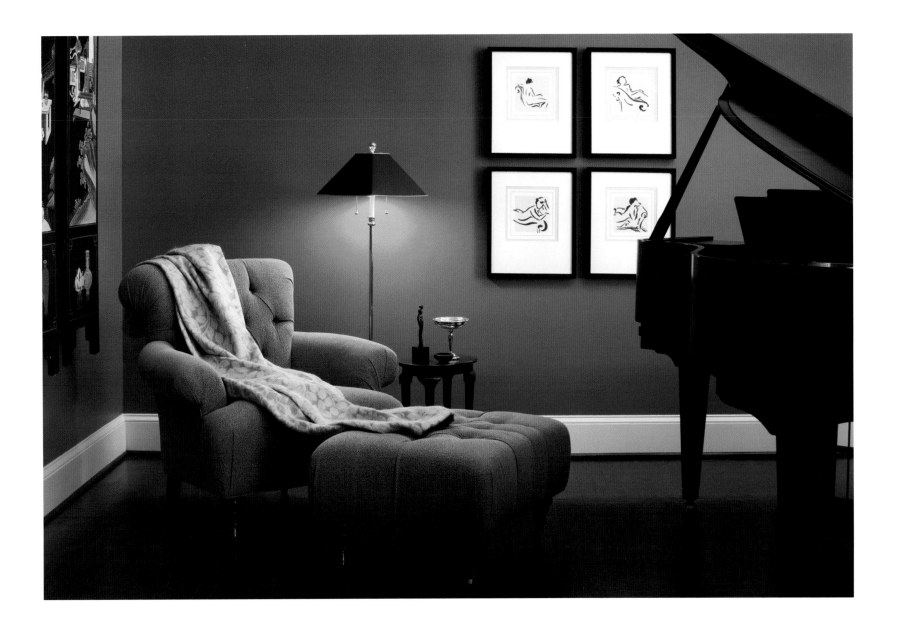

More about Dani…

WHAT'S THE MOST CHALLENGING PART OF BEING A DESIGNER?

Time allocation.

WHAT'S THE HIGHEST COMPLIMENT YOU'VE RECEIVED
PROFESSIONALLY?

Brad Bloom, vice president of sales for Pollack & Associates, a high-end fabric line, said, "In my book, Dani James is one of a small group of elite designers who lives to promote design. Only 10 percent of designers I work with have the level of professionalism that she exudes."

WHAT'S THE MOST UNUSUAL DESIGN OR TECHNIQUE YOU'VE USED IN
ONE OF YOUR PROJECTS?

One of the most unusual designs I've created was a whirlpool tub face constructed of custom textured, embossed, kiln-formed glass panels back lit with neon light roping.

CROSSROADS INTERIORS
Dani James
65 Street of Dreams
Village of Loch Lloyd, MO 64012
816.322.6417
www.crossroads-interiors.com

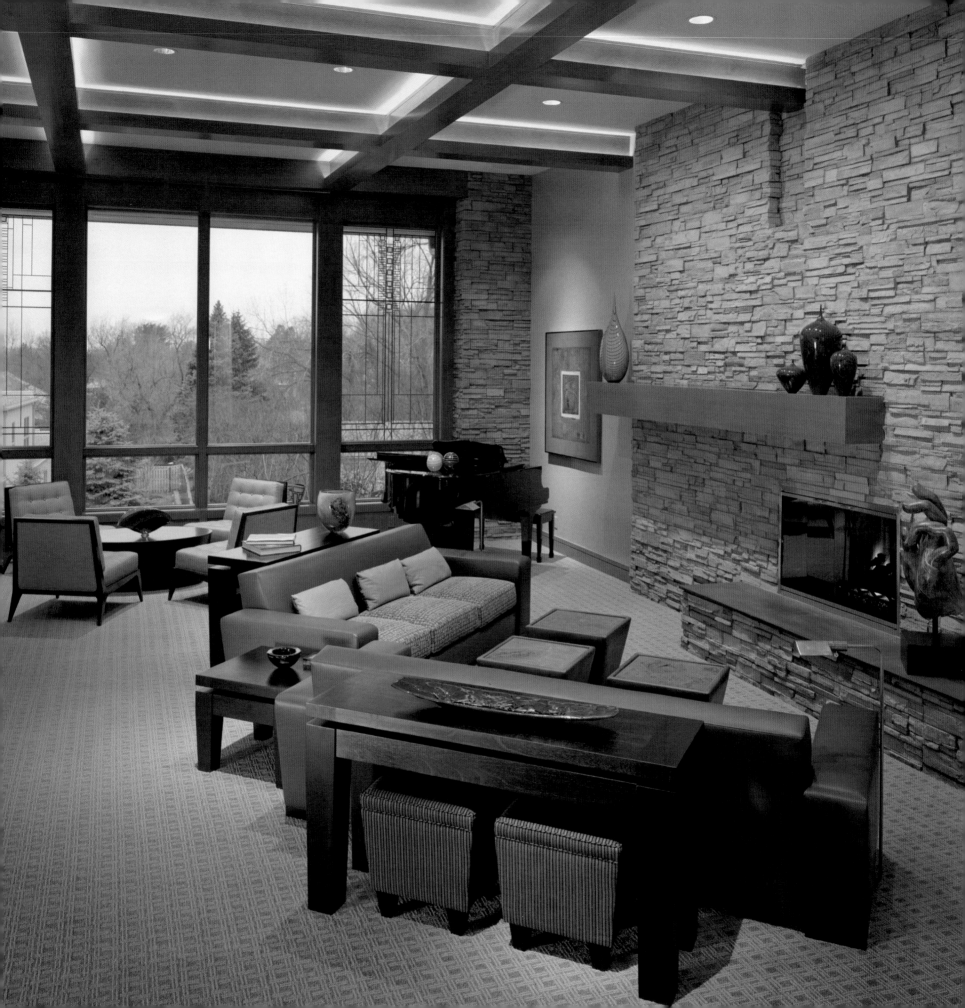

LORI M. KREJCI

Avant Architects, Inc.

Growing up with a father who is a developer, working in the construction field, and loving art were major inspirations for Lori M. Krejci. She studied architecture at the University of Nebraska and worked for several residential and commercial firms before she opened her own business 18 years ago. Her goal was to gain greater design freedom. "Not all firms allow you your own design expression," she says. Going out on her own was a big leap, but she felt it was "then or never. I was single, didn't have children, and had paid for my Ford Pinto," she says laughing. "I couldn't afford not to try."

Lori started alone, but her workload has steadily increased as her reputation for clean-lined, classic contemporary design has spread. More Omaha residents are also gravitating toward that look, Lori believes, as the city's downtown loft movement has gained momentum. Her firm now includes six other architects, one interior designer and two support staff. They focus on residential and commercial architecture and interior design.

Lori's inspiration for architecture ranges from Mies van der Rohe to Zaha Hadid and Santiago Calatrava. For design inspiration, she heads to Chicago and Minneapolis, but she also credits the design representatives who visit her office as well as the Internet. "It's so easy to keep up to date with the latest trends since all the good design catalogs are now online," Lori explains.

The contemporary trends that Lori is currently enamored with are an increased number of natural textured materials such as slate and wood, especially exotic ones that have become more affordable because of technological advances. Among her favorite woods are zebra, fiddle back maple, lace and rift-cut oak. For furnishings, she likes incorporating classics such as Eames and Corbusier, but she also likes to throw in a surprise element such as a chair upholstered in purple leather. "I like when people say, 'wow, you put that on that chair! I want design to be fun,'" she explains.

ABOVE
A glass vessel reflects beauty atop the custom wood vanity.
Photograph by Tom Kessler

LEFT
Clean lines and textures of leather, wood, stone and fabric pull this living room together, while lighting and layering techniques add depth.
Photograph by Tom Kessler

AVANT ARCHITECTS, INC.
Lori M. Krejci, AIA
3337 North 107th Street
Omaha, NE 68134
402.493.9611
www.avant-architects.com

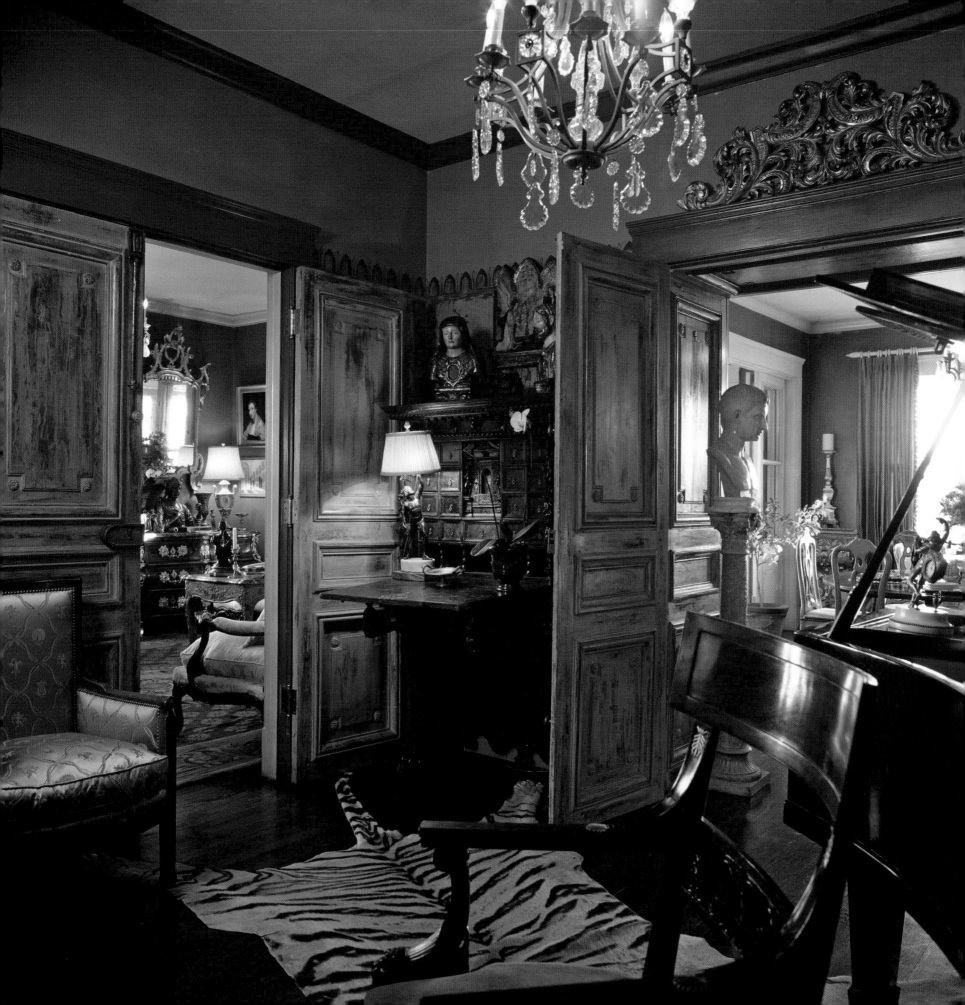

Scott Lindsay

Scott Lindsay Antiques & Interiors

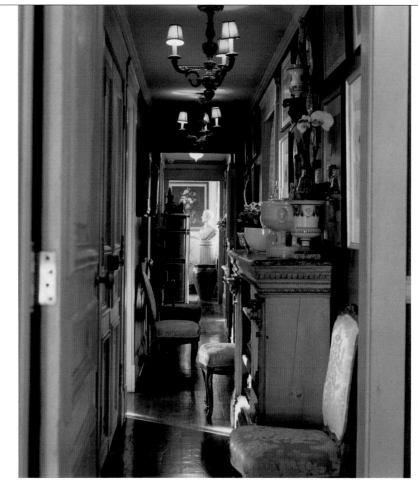

Some designers are content creating beautiful interiors. Scott Lindsay has done that well and for almost 50 years. But he also brings to his clients two additional benefits: an extensive knowledge of architectural history, design and antiques.

Scott gained his expertise from listening to scholars and visiting important sites to see firsthand a Greek column, Palladian villa, Thomas Jefferson's Monticello home or George Washington's Mt. Vernon.

His interest extends back to high school when he considered studying architecture but worried how he would make a living. He instead dabbled in design while studying business in college, including redoing his fraternity house. He soon decided, however, to switch to his college's design school and has never looked back. "I've enjoyed a wonderful quality of life, traveled and met wonderful people," he says.

Scott took his first trip to Italy and England in 1967 to study the 16th-century classic work of architect Andrea Palladio with professor Guy Roop of the University of Southern California, who was writing a book on villas. Scott found the work an immediate inspiration. "I didn't know anything about him before, but I had always liked classic architecture after *Gone with the Wind* at seven years of age," he says.

What appealed to him was the architecture's purity. "Palladio liked simple designs; it was often the owners who wanted something more frescoes to embellish," Scott explains.

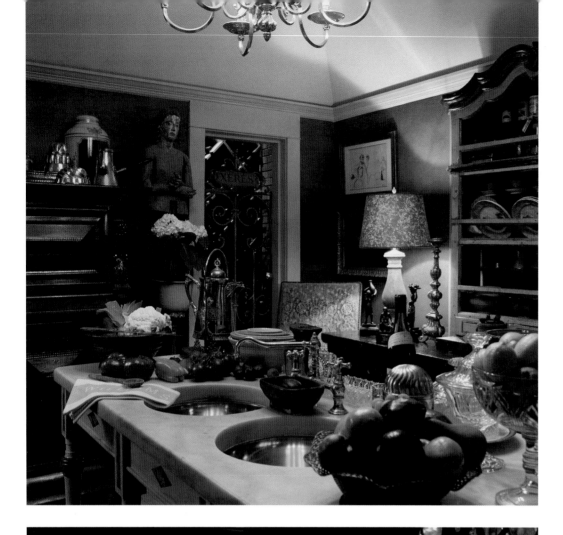

He began to learn and appreciate antiques from dealer Esther Buschman, who took him along on buying trips.

Almost five decades after becoming a designer, Scott still believes that his preference for Italian Renaissance, 18th-century French, Italian and early 19th-century French and English architecture, interiors and antiques remains the most majestic and exciting. He also believes that a classic building does not stand alone; the property surrounding it is an integral part of the architectural design and should not have a modern addition up against the building.

The desire that first pushed him to design continues to excite him, particularly when he's talking about projects that he's busy with or antiques he's found. For one set of long-time clients, he's helping them create a Palladian-style main house

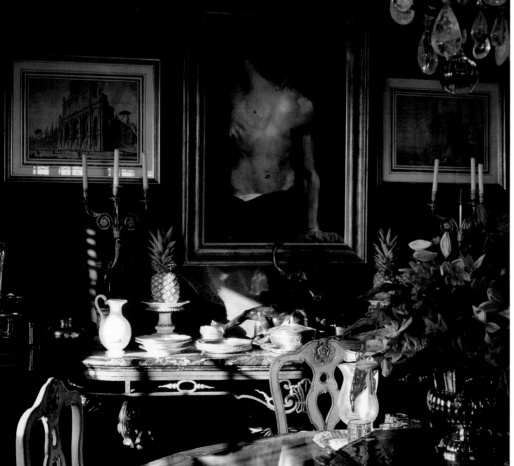

TOP
Scott doesn't want his kitchen to look like one. An old marble top from a candy shop holds two brass sinks. An 18th-century Chinese altar table is topped with a 17th-century painted Italian shelf. Antique accessories and dishes create a feast for the eyes.
Photograph by Bill Mathews

BOTTOM
Pomegranate antiqued walls provide a stunning background for the art and antiques. 18th-century Venetian ballroom chairs surround the 17th-century table. A 19th-century rock crystal chandelier lights the room with romance enhanced by antique dishes and silver and bronze dore candelabras.
Photograph by Bill Mathews

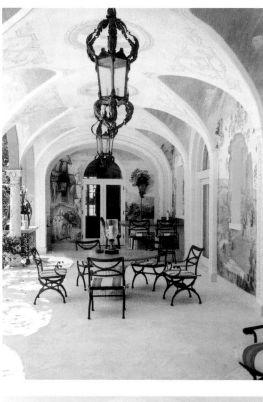

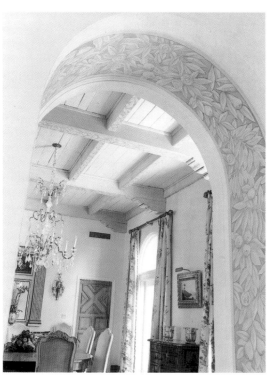

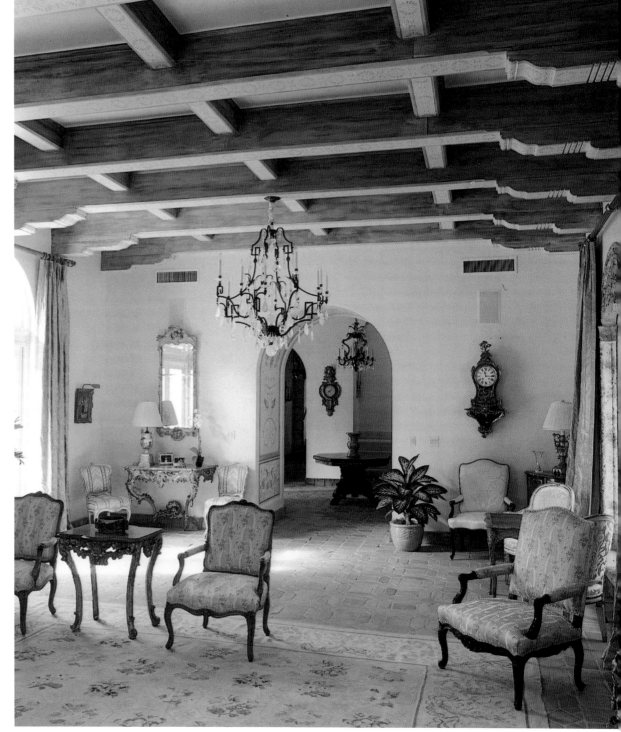

ABOVE
The salon boasts a very rare Bessarabian carpet, Fortuny draperies, French Regence and Louis XV period fauteuils, and custom-designed rock crystal chandeliers. All 18th-century furniture and accessories: Danish mirror, a French Louis XV console, a stamped Louis XV commode cira 1750 are French. In the background is the entry foyer with an octagon 17th-century table and a rock chandelier above.
Photograph by Aleksander Popovic

TOP LEFT
Aleksandar Popovic of New York frescoed the Loggia which was redesigned by Scott. Casata stone floors and bar with Rosso Verona top and panels, handmade brass light fixtures, cushion and arched french doors from the dining room open to the loggia.
Photograph by Aleksander Popovic

BOTTOM LEFT
The dining room features an 18th-century Italian commode, French console and Trumeau, rock crystal chandelier and antique Oushak carpet giving this room a very formal and elegant ambience. My clients dine here every night.
Photograph by Aleksander Popovic

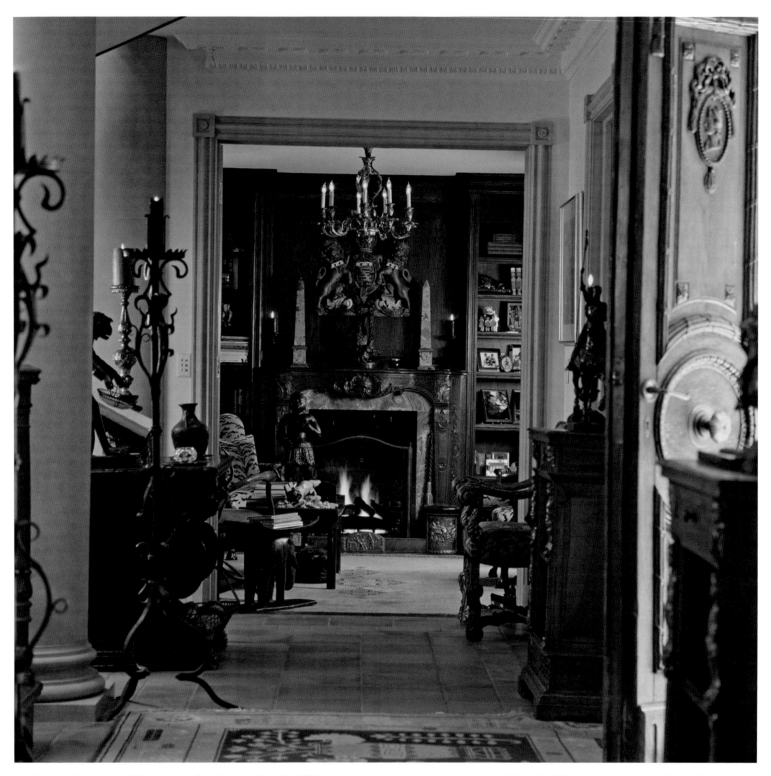

and guest house on 10 acres in the Virgin Islands. "We've done a wonderful round entry with a dome and a staircase that cantalevers," he says. For another client, he designed an octagonal entry with wings that angle off in front and back to maximize the small lot and offer privacy.

Don't expect such spaces and others to resemble staid, museum-like rooms. Scott relishes using exuberant color to make rooms come more alive. In his own home, both his living and dining rooms are pomegranate colored, with the living room walls upholstered in silk damask accented with gold leaf and the dining room walls glazed. Pomegranate and peach are his favorite colors because of their cheerfulness and warmth.

Whatever look he fashions, the goal remains the same, he says: "To create a more beautiful lifestyle for my client. If you have not raised

the level of your clients' taste and lifestyle, you have done them an injustice." He's also gained a loyal following because of his honesty. "If clients wonder where something is, I just say I forgot to order it, which doesn't happen often; I tell them, rather than make up a story."

The highest compliment he says he's received was: "Your work looks like we have inherited our antiques and that you worked on the design for years."

If Scott stops decorating, when he is 75 to 80 years, he says he'll continue to deal in antiques. "You can be 90 and still sit in a wonderful chair and sell," he says.

RIGHT
The residence of Carolyn Williams: A 17th-century tapestry hangs over the 17th-century stone fireplace mantel. A Spanish Colonial door is used as a coffee table; 18th-century Venetian columns anchor the corners of the room. Mrs. Williams likes a mixture of styles and accessories that are fun, interesting antiques that cause you to smile.
Photograph by Bill Mathews

FACING PAGE
In Mrs. Carolyn Williams entry foyer a pair of 18th-century front doors from a villa in France (that Scott Lindsay had kept for 25 years hoping to use for himself) are flanked by a pair of 17th-century bookcases and a desk. Foreground library: antique mantel, crest, and chairs in silk and velvet leopard woven design. Scott designed all architectural details for this home.
Photograph by Bill Mathews

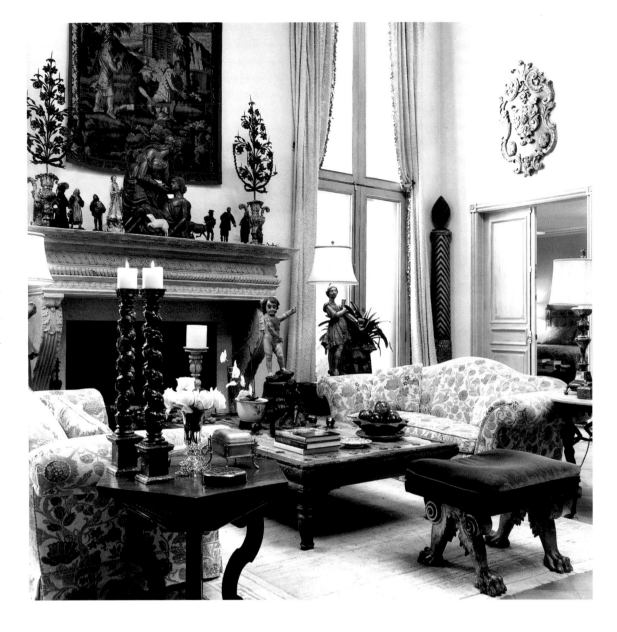

More about Scott…

DESCRIBE YOUR STYLE OR DESIGN PREFERENCES.

Italian Renaissance (16th and 17th century), 18th century French, 18th century Italian and early 19th century French and English.

WHO HAS HAD THE BIGGEST INFLUENCE ON YOUR CAREER?

Antique dealer Ester Buschman.

WHAT SEPARATES YOU FROM YOUR COMPETITION?

I use antiques almost exclusively!

WHAT COLOR BEST DESCRIBES YOU AND WHY?

Peach and pomegranate are cheerful, exciting and warm.

HOW LONG HAVE YOU LIVED IN THE HEARTLAND? PRACTICED IN THE HEARTLAND?

72 years, practiced 48 years.

SCOTT LINDSAY ANTIQUES & INTERIORS
Scott Lindsay
3800 Baltimore Avenue
Kansas City, MO 64111
816.561.5086

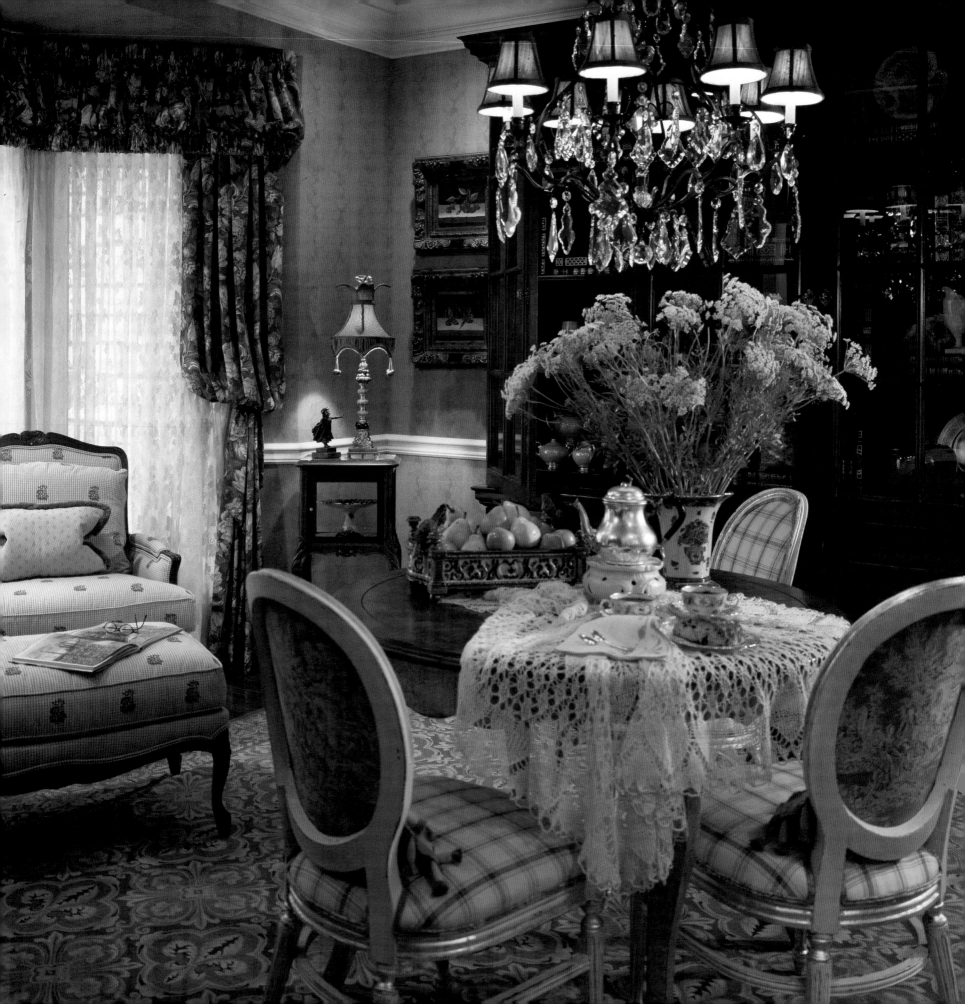

TOM MANCHE

Tom Manche Interiors, LLC

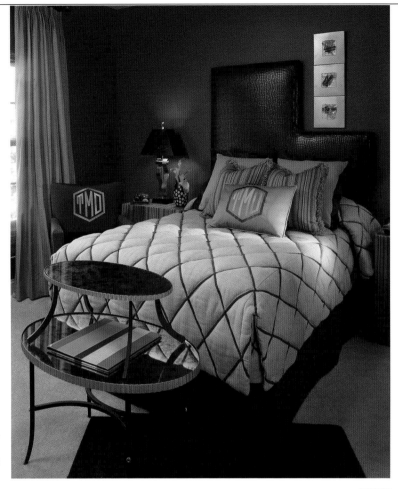

Tom Manche considers himself a romantic and Renaissance man. His interiors reflect that spirit. The rooms he designs for St. Louis clients are colorful, filled with special furnishings and accessories, and decorated in a traditional or classic contemporary way that reflects their personal taste.

Tom didn't study design. Until 15 years ago, he was a successful fine jewelry salesperson who listened to his customers' desires. With friends urging him to use the talent they recognized in his own home, he switched to interior design.

Unlike competitors who travel beyond the Heartland to find resources, Tom is happy with what he finds in his own backyard. To give back to the community where he's always lived, he's active in arts organizations where his talents benefit worthy groups such as Dance St. Louis, The Arts & Education Council and the St. Louis Symphony Orchestra.

Tom has found his calling. "When you have a job you love, you're the luckiest person in the world, and if you love what you do, you'll be successful," he says. Both have happened.

But the best reward, he says, is the praise clients pay him when they say, "You read my mind." He has, he says, simply listened well to affect his motto: "Whatever your style, wherever your space, it's all about you!"

ABOVE
A classic contemporary, masculine bedroom created for the St. Louis Cardinal Glennon Children's Hospital Designer Showhouse.
Photograph by Alise O'Brien

LEFT
This client desired a dining room that was French Country in ambiance and function, including a space to snuggle in a comfortable reading chair.
Photograph by Alise O'Brien

TOM MANCHE INTERIORS, LLC
Tom Manche
7478 Stratford Avenue
University City, MO
314.727.3139

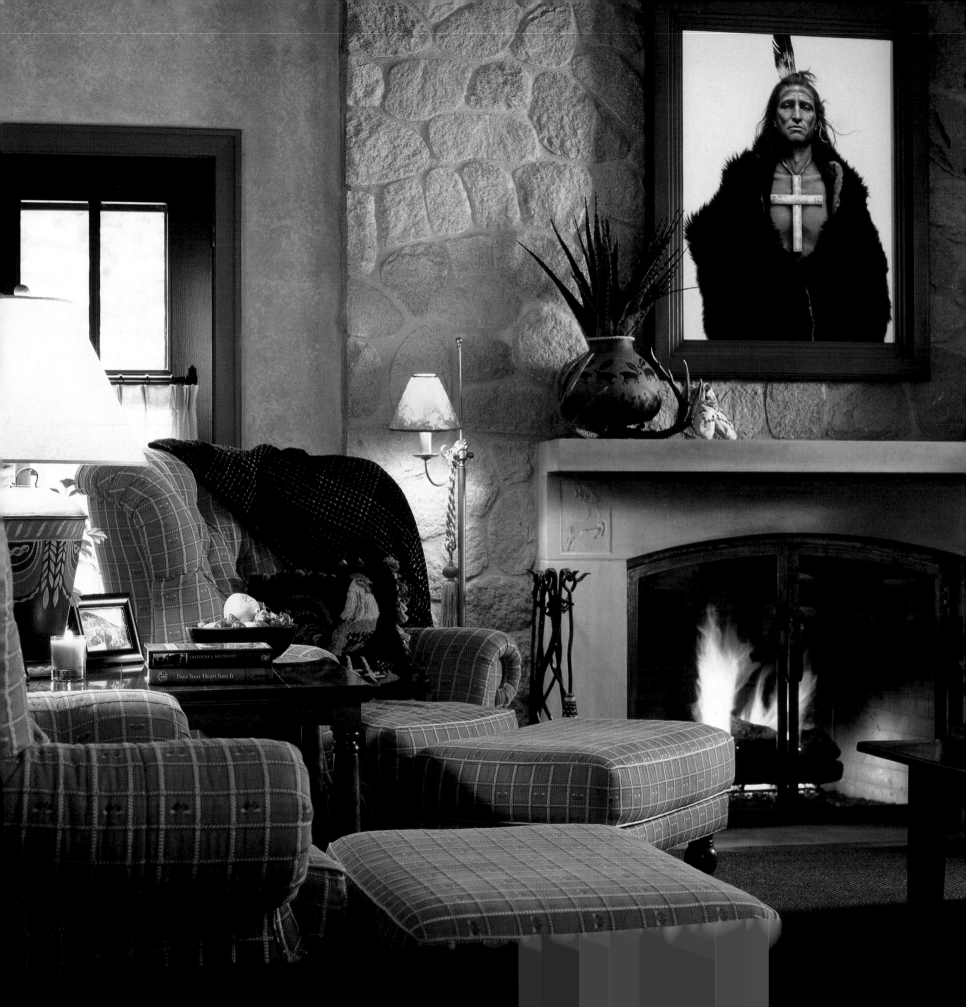

KAREN MARCUS

Karen Marcus Interiors, Ltd.

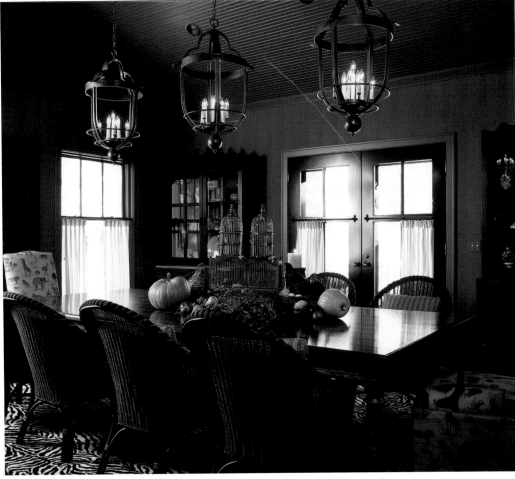

Don't try and pigeonhole Karen Marcus. The Kansas City-based designer considers herself shy, but there's nothing retiring about her favorite Chinese red color or the exuberant interiors she creates for clients, some of whom have hired her to design their primary and vacation properties.

A designer for 36 years and with her own firm since she moved to Kansas City 32 years ago, Karen has received one of the best compliments a professional can. She is now decorating homes of some of her clients' offspring.

A design career was always her plan. She studied at the University of Arizona and began her training in New York where she came to greatly admire legendary masters Billy Baldwin and Mark Hampton. They taught an important lesson that she still follows: Keep interiors simple and understated. "Too many professionals and homeowners gild the lily. They don't know when to step back and stop," she says. From another design legend, the late Californian Michael Taylor, she learned the importance of the right scale.

Karen's Midwestern clients agree with these approaches since they're "very natural, unpretentious people," she explains. Her dislike of pretension comes through when she cites a pet peeve: "a strong disdain for new, overly large houses that are too close together and have too-high ceilings."

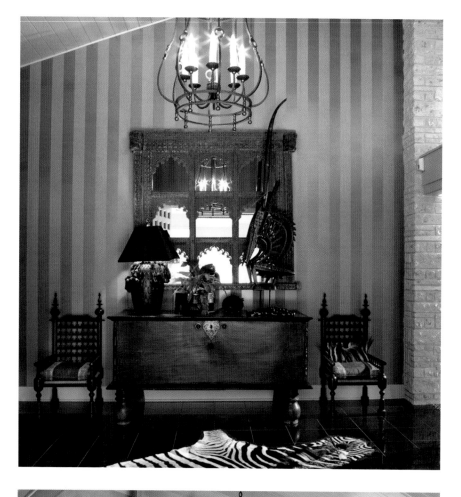

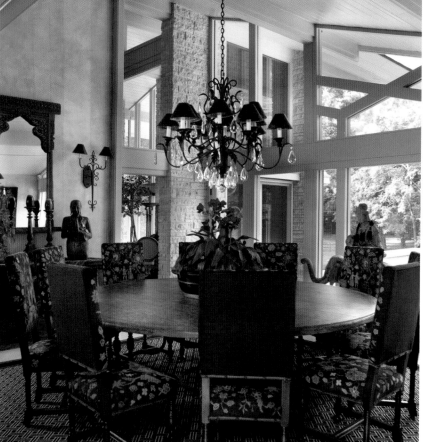

Karen's clients come to her for other reasons, she says: her professionalism and ability to be timely, attend to details, be honest and always follow through. Her reputation, which has spread, in part through word-of-mouth and through exposure in national and local shelter publications; including the November 2005 issue of *Architectural Digest* and her Heartland location since it's central and easy to get to from either coast. Although Karen was born in California, she ended up in the Heartland, as did her sister Pat Wormhoudt, another designer in Wichita (see pg. 107).

Karen expects clients to share with her their likes and dislikes, but she also wants them to trust her instincts, which tend to fall into the transitional style-a-melding of the best traditional and contemporary elements, from deep rich wall colors to Asian antiques, textures, and few patterns, perhaps a paisley fabric or Oriental rug. In front of a dining room window in a Kansas City home, she placed a Tibetan monk on a stand. A zebra rug and Coromandel screen are juxtaposed in a foyer in an Arkansas home.

Karen has a talent for combining diverse parts seamlessly. In a Colorado-style farmhouse, she painted walls turkey red and saffron yellow to add to the desired aged aesthetic, yet there's nothing dated or rustic about the elegant plump seating and artworks.

TOP An antique trunk from Sri Lanka is flanked by a pair of Bali chairs and topped with an African antelope headdress. An ancient window from India is backed with a mirror.
Photograph by Bob Greenspan

BOTTOM Hand trowelled fresco walls harmonize with the Texas limestone columns. A set of 12 French antique needlepoint chairs surround the round custom table. Tibetan monk kneels on the antique French coffer.
Photograph by Bob Greenspan

FACING PAGE Texas limestone, soaring windows and beams create a daunting 60-foot living space. The six-foot mask is African and the column to the right holds one of a pair of Afghani totems.
Photograph by Bob Greenspan

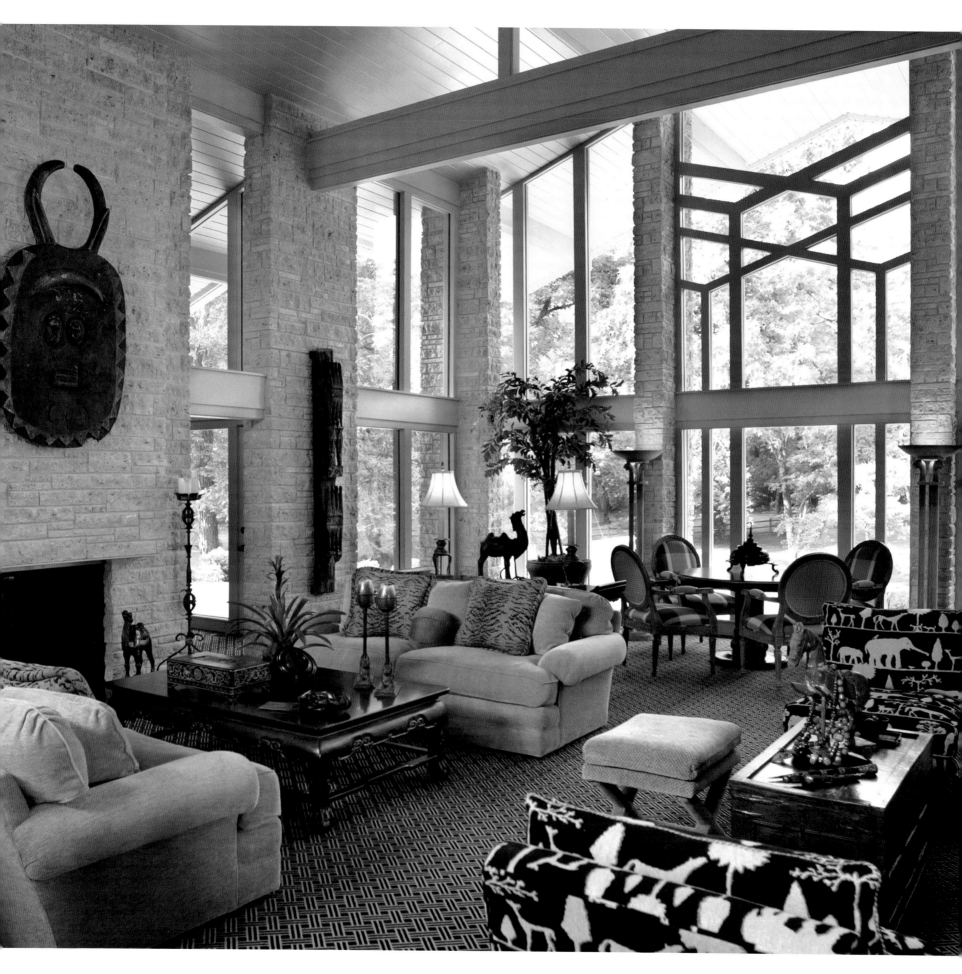

Karen is also proud of her ability to inject surprise in a room. In a Florida condominium, she painted most ceilings a robin's-egg blue, which continued the color of the sky and water, both of which are visible since she prefers simple window treatments. In other jobs in warm climates, she favors equally muted palettes. "When it's blistery hot, you need soothing colors," she explains.

And while some observers say design can easily become a drawn-out process, not so with Karen who's known for working quickly, decisively. Rather than confuse clients with numerous trips to showrooms and piles of samples, she asks them questions that get at the heart of what they like and how they live. "I ask them how they spend their time, want to use a room, whether they like to read or watch TV," she says. She learns quickly. One client's critique says it all: "I love your class, style and you."

The legacy she'd like to leave is to help raise the visibility of fellow Heartland designers. "We get so little national recognition; it's always the East and West Coasts. We have many good designers here." Many put her at the top of that list.

ABOVE
A palette of sunny yellows and leafy greens form a wonderful background for this couple's magnificent art collection, including many by Francoise Gilot.
Photograph by Bob Greenspan

FACING PAGE LEFT
Karen, in her own home, pulled sage and terra cotta from a 10-panel Coromandel screen. An antique Boddhavista with straw hat and beads stands atop an antique tansu chest.
Photograph by Bob Greenspan

FACING PAGE RIGHT
A 19th-century French cabinet creates a charming vignette at the end of a hallway.
Photograph by Bob Greenspan

More about Karen...

DESCRIBE YOUR STYLE OR DESIGN PREFERENCES.

Classic contemporary with Asian influence, deep rich color, simplicity and little use of pattern (except paislies), lots of texture.

WHO HAS HAD THE BIGGEST INFLUENCE ON YOUR CAREER?

Michael Taylor for scale, Billy Baldwin (who I knew in New York City) and Mark Hampton.

WHAT SEPARATES YOU FROM YOUR COMPETITION?

Professionalism, timeliness, attention to detail, honesty and follow-through.

WHAT EXCITES YOU MOST ABOUT BEING PART OF
SPECTACULAR HOMES OF THE HEARTLAND?

We get so little national recognition—it's always the East and West Coasts. We have many good designers here.

WHAT COLOR BEST DESCRIBES YOU AND WHY?

Chinese red. It's warm and inviting.

KAREN MARCUS INTERIORS, LTD.
Karen Marcus
4454 State Line Road
Kansas City, KS 66103
913.384.3133
www.karenmarcus.com

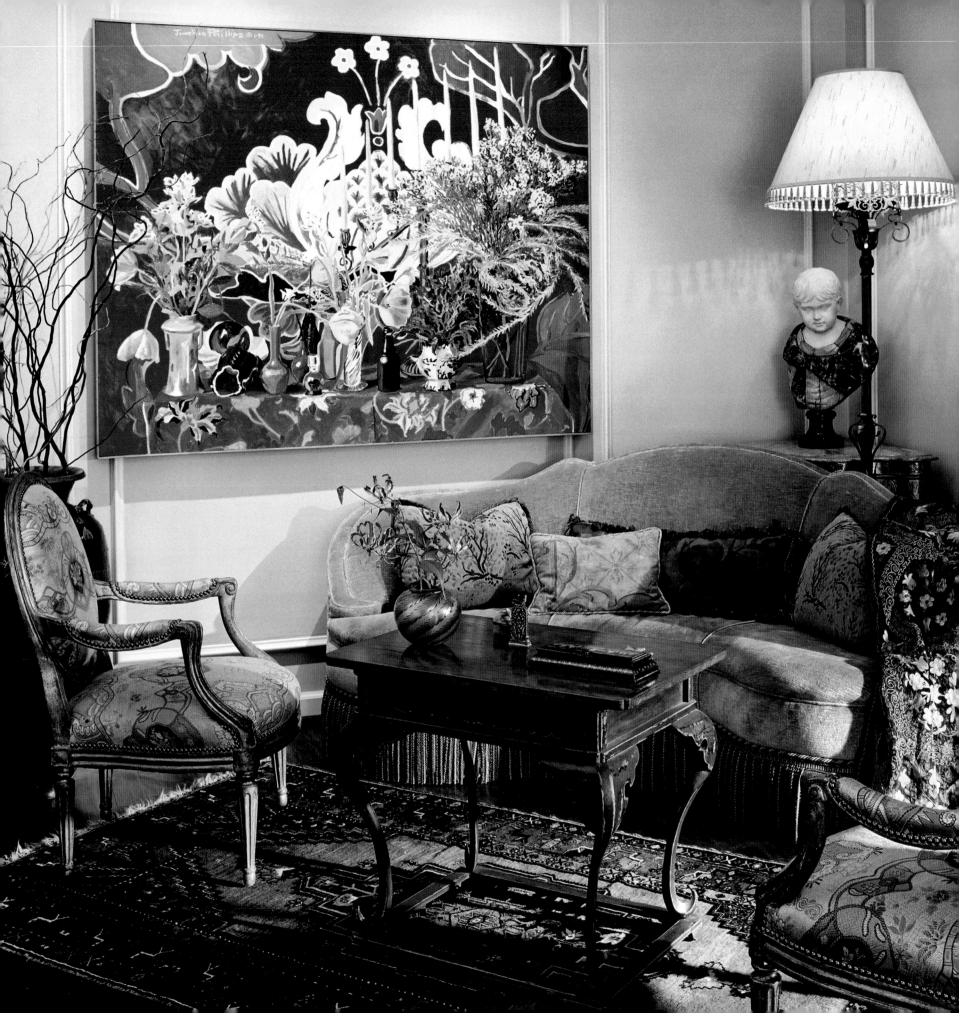

JERRY OLSON &
BOB BLACKBURN

Olson-Blackburn Interiors, Inc.

RIGHT
Walls upholstered in hand-printed scenic fabric quiet the powder bath in a Lawrence, Kansas home.
The carved vanity base is fitted with a deep green honed granite top and travertine lavatory.
Photograph by Gavin Peters

LEFT
The vivid color and sensuous shapes in this contemporary painting are in striking contrast to the
rich, but subdued, palette of this Wichita, Kansas living room.
Photograph by Gavin Peters

Few trends may start in the Heartland but that's fine, according to Bob Blackburn, partner with Jerry Olson in a Wichita, Kansas firm.

"Most trends that make it here have staying power, which is what we care about. Our work isn't about the latest fad," says Bob. Frequent visits to design centers and other cities keep their vision fresh.

The duo has fine tuned their partnership over the last 21 years. They usually work together on large projects, although they assist some clients individually. The strength of the firm is based largely on sharing ideas throughout the design process. They've also mastered blending quality and service with a relaxed, fun approach that typically begins in clients' homes to understand how they live.

"There is no Olson-Blackburn 'look,'" says Jerry. "We can be practical, without being boring, or we can be wildly extravagant. The question we always pose is 'Is it appropriate?'"

That's their prime goal—to create timeless interiors that run the gamut from traditional to soft contemporary while reflecting their clientele.

"We spend a great deal of time with our clients," Bob says. "It sounds like a cliché, but they are the best part of our job."

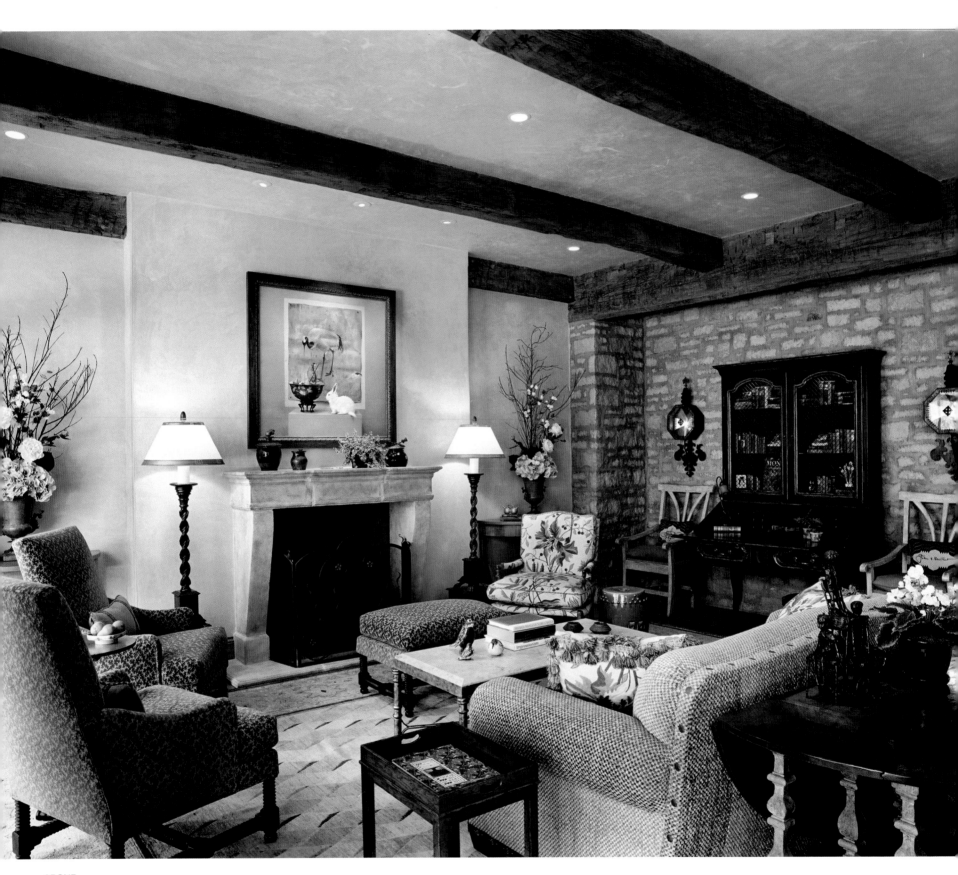

ABOVE
Stone walls and reclaimed materials including hand-hewn beams and oak
flooring create a rustic ambience in the living room of this Lawrence residence.
Photograph by Gavin Peters

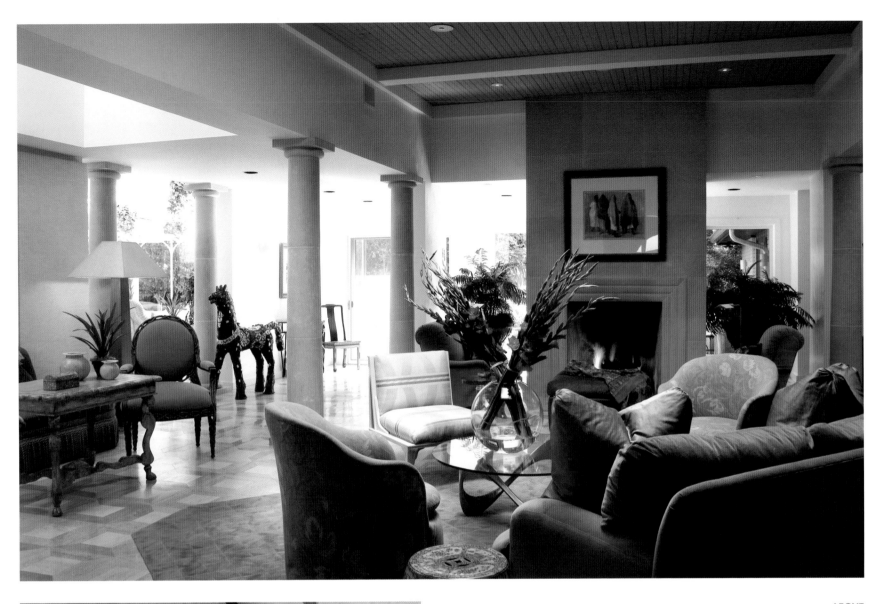

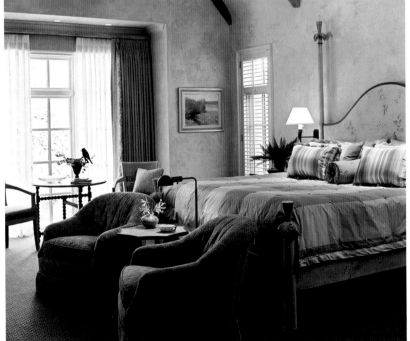

ABOVE
Olson and Blackburn assisted the owners of this Wichita home through several rounds of renovation to achieve this exotic space.
Photograph by Gavin Peters

LEFT
The hand-painted Italian bed, dressed in striped and plaid taffetas, embroidered curtains, and deeply comfortable lounge chairs lend an elegance to the master bedroom of this Lawrence residence.
Photograph by Gavin Peters

OLSON-BLACKBURN INTERIORS INC.
Jerry Olson
Bob Blackburn
240 North Rock Road, Suite 200
Wichita, KS 67206
316.652.0818

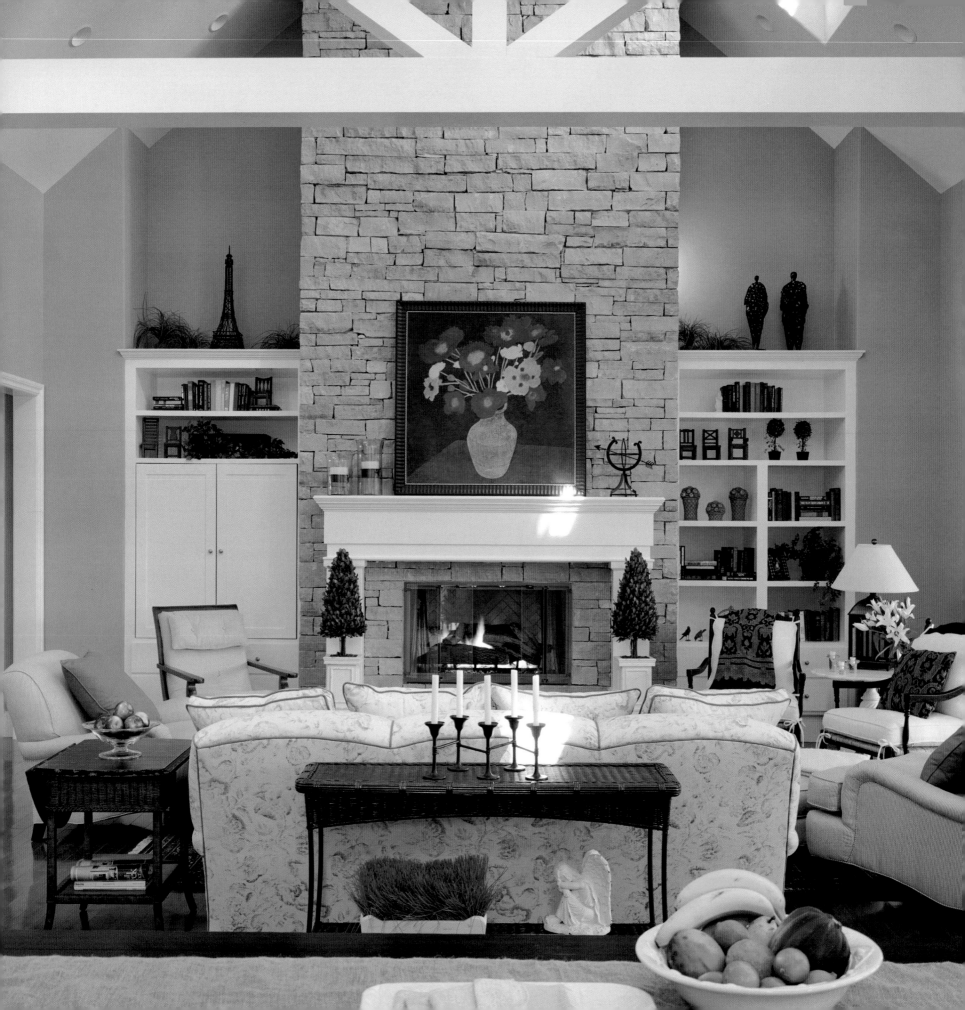

JUNE ROESSLEIN

June Roesslein Interiors

June Roesslein knew from a tender age that she wanted to work in the design field. As a child, she often accompanied her father, a builder, to his construction sites. Once married, she worked for a contractor and designed his display rooms, then worked for a builder who taught her more about drafting and specifying materials.

Today, the firm that bears her name, June Roesslein Interiors, employs 17, and the company's projects focus on decorating builders' display homes and residential projects. The challenge to satisfy both clients is quite different.

For builders she creates rooms that reflect the price range and tastes of their prospective buyers. She knows to fashion a "wow" look from the moment they walk in. "You win or lose them within the first six seconds they're in the front door," she says. For homeowners, the goal is to find their style preferences.

Both types of work share similarities, too. The lifestyle of St. Louisans has become more casual. "Almost all of us want our homes to be functional and comfortable and focus on outdoor living," says June who divides her time among her family's homes in suburban St. Louis, at the Lake of the Ozarks, Missouri, and at Hilton Head, South Carolina, each fashioned in a distinct style. The company's attention to detail is also always fastidious, and staff work with resources locally and nationally to find the best possible products, materials and accessories.

ABOVE
This vignette is viewed from the entry showing the way to the lower level. Simple, informal lines reveal the welcoming style of the entire home.
Photograph by Alise O'Brien

LEFT
The great room is part of the kitchen and dining area. It is the space where everyone gathers for relaxation, fun and dining. The beamed ceiling is a beautiful focal point.
Photograph by Alise O'Brien

JUNE ROESSLEIN INTERIORS
June Roesslein
17899 Chesterfield Airport Road
St. Louis, MO 63005
636.394.1465
www.juneroesslein.com

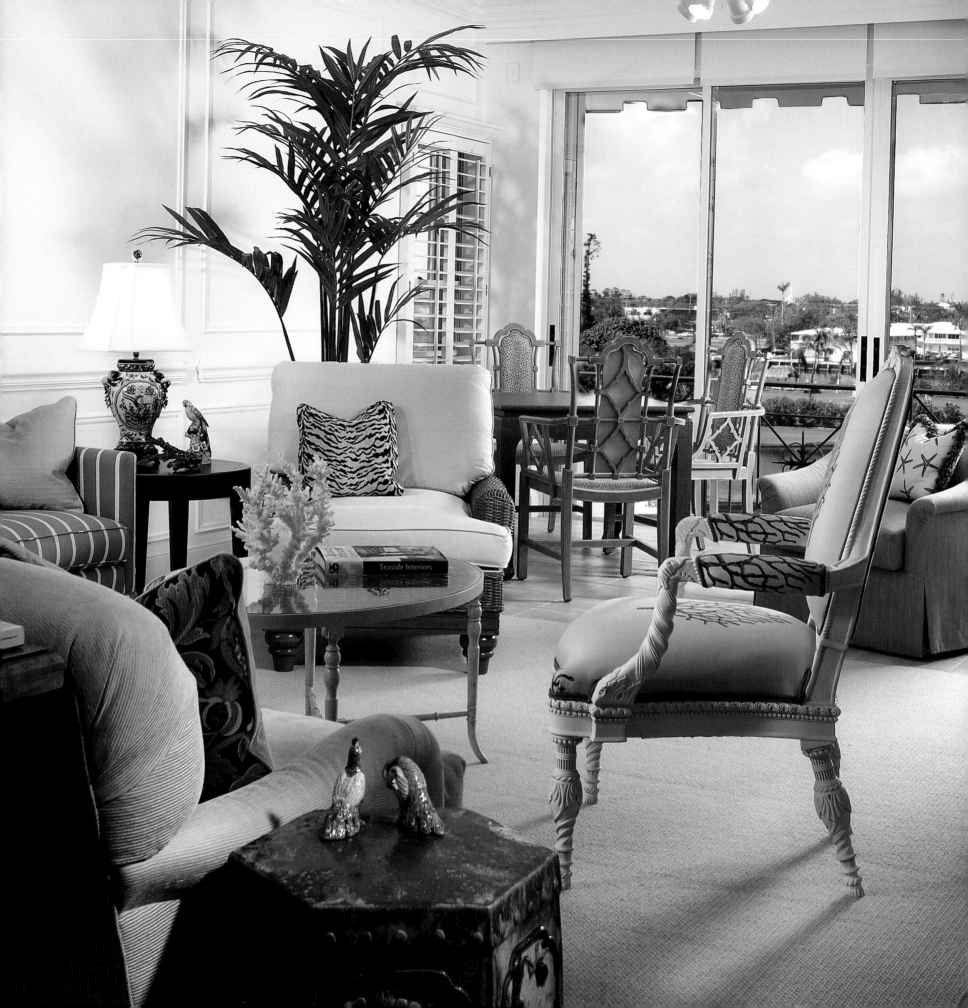

JULIE ROONEY

Julie Rooney Interiors

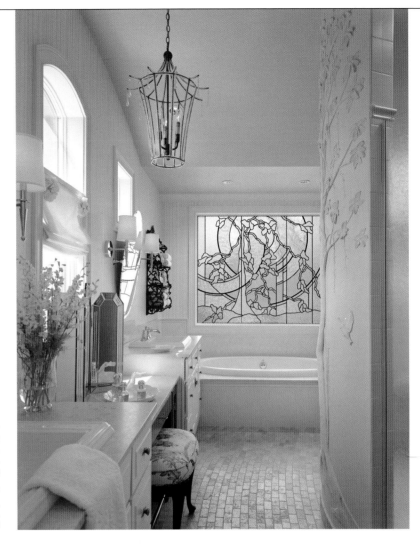

RIGHT
St. Louis master bathroom collaboration: Julie Rooney and Chris Berry, ASID. This moderately sized bathroom packs in desired bells and whistles. Curved shower wall adorns a plaster wall sculpture which extrudes to the vaulted ceiling, and is complemented with textured art glass over tub.
Photograph by Alise O'Brien, St. Louis

LEFT
Florida living room overlooks golf course and inter-coastal waterway. Homeowners enjoy entertaining, reading, music, TV and a spectacular sunset in this light and airy colorful space.
Photograph by Daniel Newcomb

Julie Rooney, ASID, has strong ties to St. Louis because her family has lived in the area for four generations. If there's one thing that characterizes Julie, it is that her interiors—and wide range of skills—are a study in contrasts. As the owner of Julie Rooney Interiors, a 10-year-old interior design firm in St. Louis, Julie's design team serves both corporate and residential clients. As an example of her versatility, she has adorned one Southwest Bank branch with a Dale Chihuly glass chandelier while decorating other branches with Cardinal baseball photo collections.

Julie's interiors showcase several integral constants. Nearly all of her interiors feature one breathtaking piece of art, indeed for a number of years she worked in the art business. The second constant of Julie's designs is her focus on applying lighting design that complements a room's purpose. She selects fixtures that create ideal balances between light and shadow.

With college degrees in interior design and accounting, Julie brings a transparent and businesslike approach to her client relationships. A significant part of the portfolio represents repeat business. She creates total

ABOVE LEFT
Scottsdale dining room characterized with tall ceiling and stone floor is warmed with rich wood table, classic style chairs, and fine art panels.
Photograph by Bill Timmerman

ABOVE RIGHT
Guest room for an owner of St. Louis Cardinals' was fashioned with Cardinal baseball artwork, photos and artifacts for guests' comfort and enjoyment.
Photograph by Daniel Newcomb

FACING PAGE
Comfortable upholstered furniture and custom-made tables are among the highlighted collection of authentic Thai artifacts inside this contemporary living room equipped with fireplace and grand piano.
Photograph by Bill Timmerman

partnerships with clients, subtly conveying their lifestyles through the details of her designs. Julie assists them throughout the entire interior design process, including consultations, designing lighting plans and deciding on selections of furnishings, finishes and accessories. With her extensive knowledge of materials, lighting, and design, Julie will act as an owner's agent on turnkey projects. She does this while serving clients' current and future needs, such as aging in place.

Julie utilized her collaborative skills while designing the interior of her mother's A-frame chalet, which is nestled in the woods on a tranquil lake outside St. Louis. "There were things she had to have," says Julie. "The challenge of bringing the outdoors in while properly placing windows, furniture and lighting was a triumph."

Julie believes that her goal-setting personality has greatly impacted her success, and has enabled her to work on interesting out-of-state projects through St. Louis contacts. "I compete with myself every day to be better than I was yesterday," says Julie.

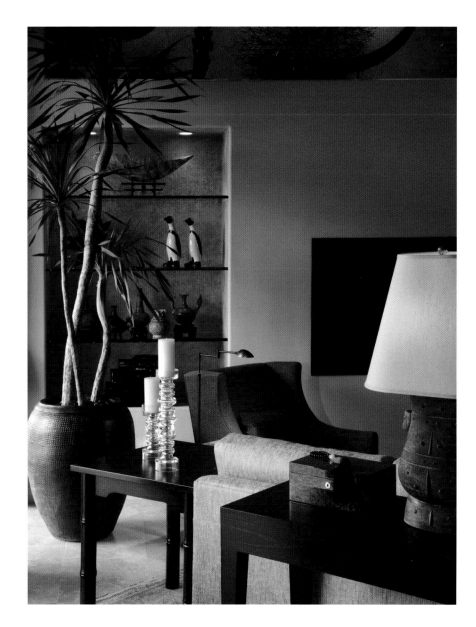

More about Julie …

DESCRIBE YOUR STYLE OR DESIGN PREFERENCES.
I prefer to be involved in a project from its inception, and adapt to various styles and client needs.

WHO HAS HAD THE BIGGEST INFLUENCE ON YOUR CAREER?
I am influenced every day by listening, learning and practicing my profession.

WHAT SEPARATES YOU FROM YOUR COMPETITION?
Not only am I a registered interior designer with discriminating taste, the company operates in a well organized business-like fashion using current technologies. Best of all, our clients have a good time through the design process.

JULIE ROONEY INTERIORS
Julie Rooney, ASID
9524 Crooked Creek Trail
St. Louis, MO 63127
314.843.2024
www.julierooneyinteriors.com

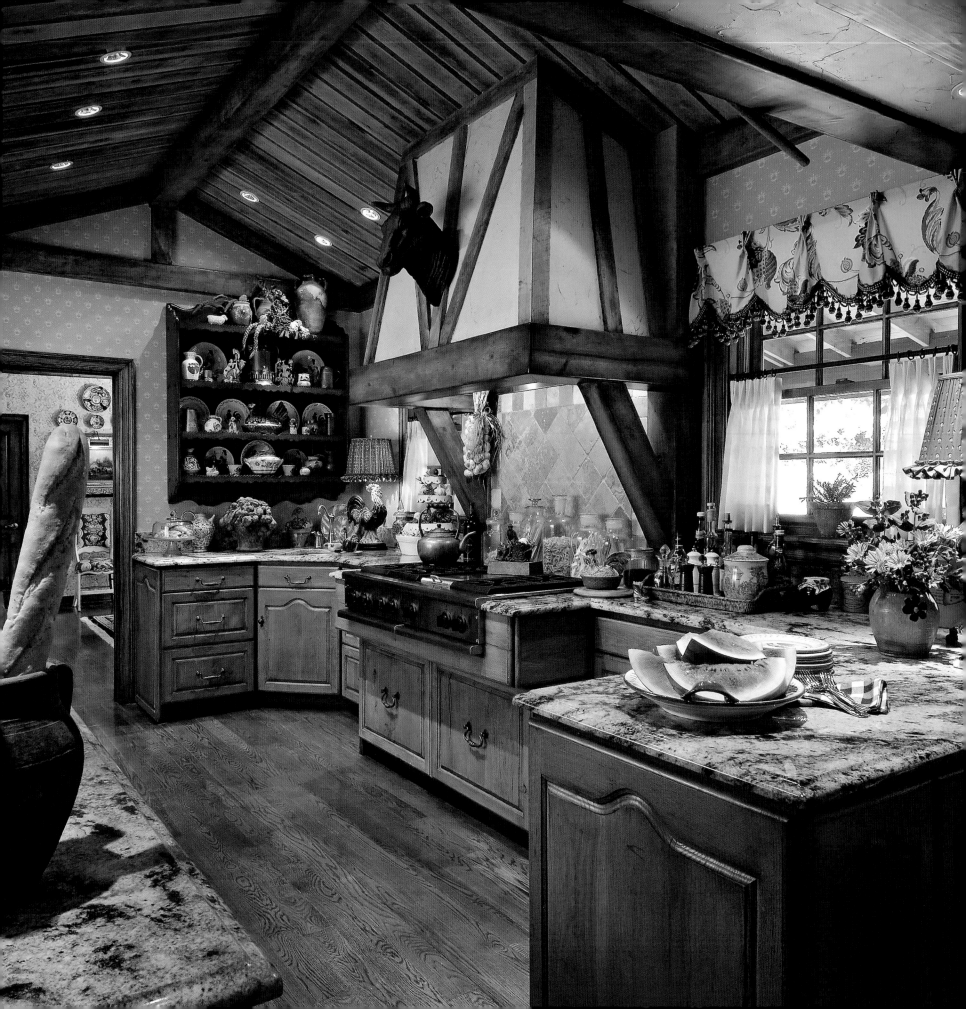

SUE SIMPSON

Zelda's Interiors

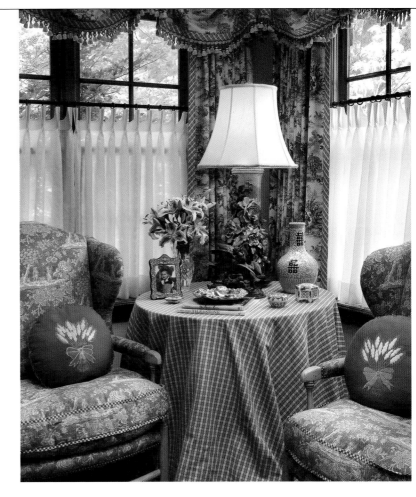

Sue Simpson came to the world of interior design from another related field—art and antiques. With enthusiasm for both, she opened her antiques shop and design studio 31 years ago, and she and her husband Barry, a well-known builder in Tulsa, began their journey working together.

"I love getting to know my clients. Home is the primary place where people seek sanctuary from their hectic lives. It's my responsibility to create a relaxing atmosphere where they can recharge," she says.

Sue prides herself on not working in a certain decorative period, although she loves to work with furniture from the 18th and 19th centuries, especially when working on contemporary designs. Not long ago, she designed a Tuscan-style home in Lake Las Vegas, Nevada. She added many contemporary elements to the traditional Italian home. "The combination worked wonderfully. When you have timeless design, you can do that," she explains.

Sue has become known throughout the Tulsa design community and beyond for her expertise in incorporating classic furniture forms, gracious room arrangements, and masterful detailing. Her rooms always revolve around a well-thought-out furniture plan that encourages collecting and arranging furnishings. Sue's work has been featured in many design magazines through the years such as *Renovation Style* and *Windows & Walls*, and also been prominent in community designer show homes for the arts.

In Sue and Barry's home in an historic area of Tulsa (pictured on these pages), Barry started with a 1920s Colonial-style home and turned it into a charming French farmhouse. By adding custom-made beams throughout the house, porches on the front and back, and textured antiqued walls, the bones of the home began to feel French. Then, with the couple's extensive collection of Country French furniture, accessories, fabrics in lively French patterns, checks, and toiles, and Sue's love of French colors such as mustards and reds, the couple soon had—voila!—their rustic French house.

The couple has worked on projects beyond Tulsa's borders—in Florida, Nashville, Austin, Santa Fe, and several in Colorado. "For 90 percent of my clients, I've worked with them over the last 20 years, which sometimes has meant doing a second or third home. You do the Tulsa look and then a Florida- or Colorado-style home," Sue says. "I never know where the job will take me."

The look in Tulsa is now changing from traditional and mostly French to a younger, simpler style, which has added great fun and a challenge for this designer. Sue, a true professional, knows that the only way to keep her business growing is to learn, watch, and adapt. "We can do that," she says cheerfully, and she and Barry have.

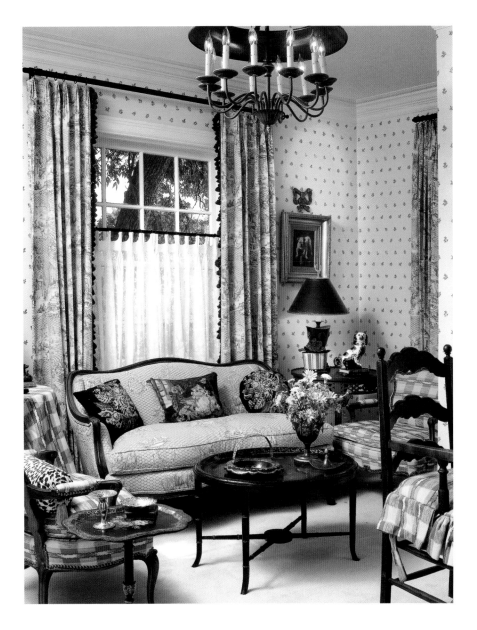

RIGHT
The love for toile shows in the cozy red toile guest bedroom. Red plaid fabric and printed red and crème walls are accented by antique black paper mache and toile pieces. The red antique toile chandelier completes the room.
Photograph by Gene Johnson

FACING PAGE TOP
The French farm look continues into the family room. Rustic beams, cabinetry, antique French furniture filled with Majolica, Faience, Black Forest and bronze pieces fit comfortably into the French setting.
Photograph by Gene Johnson

FACING PAGE BOTTOM
The rustic French dining room is center stage to the custom made French dresser, filled with antique Imari, again made by Barry. Bright red and yellow painted chairs enhance the French farm table and the antique bronze rooster, which is one of Sue's prized possessions.
Photograph by Gene Johnson

More about Sue …

WHAT PERSONAL INDULGENCE DO YOU SPEND THE MOST MONEY ON?

My home and rustic cabin in the woods. I have a love for anything that relates to home cooking, gardens and antiques.

WHAT SEPARATES YOU FROM YOUR COMPETITION?

Working with my husband gives me an advantage to have his artistic insight and to have crews on hand to build whatever is needed at a moment's notice and make the turnaround of a home much faster and easier.

YOU WOULDN'T KNOW IT BUT MY FRIENDS WOULD TELL YOU I AM…

Always on the go and never stopping.

DESCRIBE YOUR STYLE OR DESIGN PREFERENCES.

I prefer a European look such as Country French, English or Italian. I love its homey comforts, but I have done many modern homes too.

ZELDA'S INTERIORS
Sue Simpson
1111 East 24th Place
Tulsa, OK 74114
918.743.5711

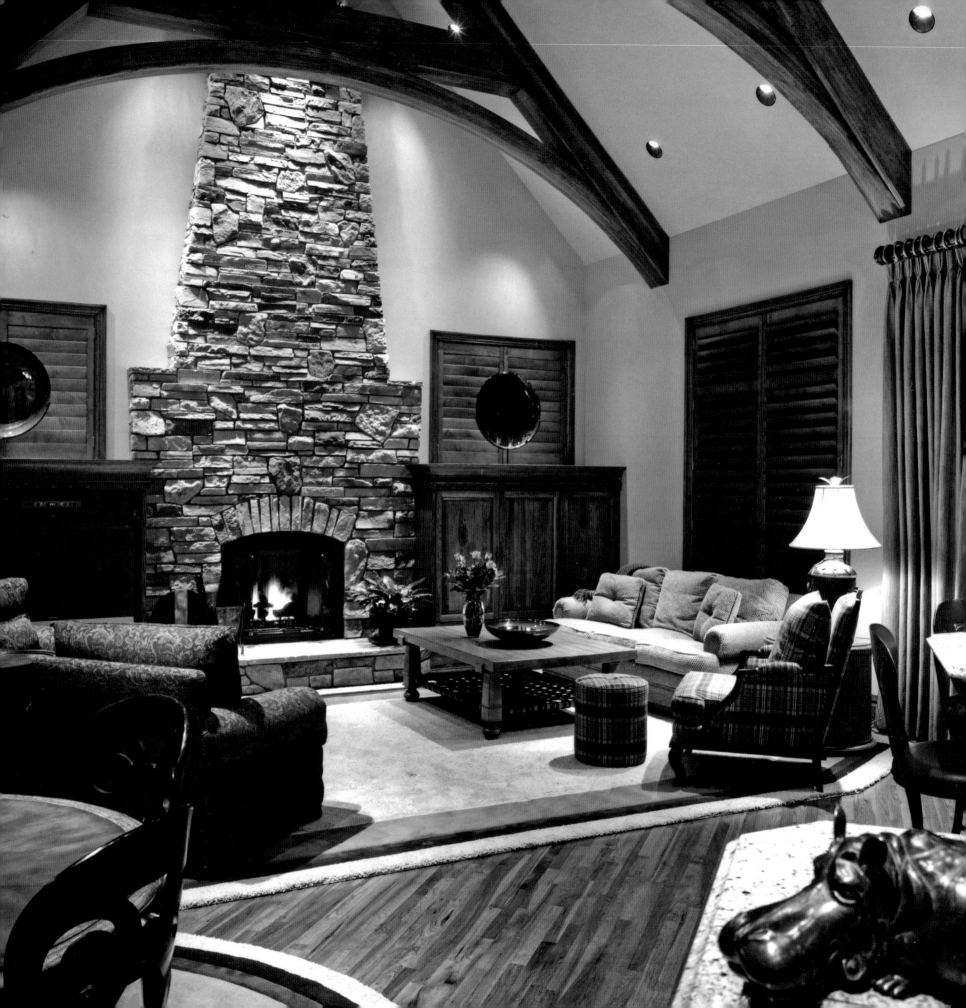

PAM STANEK

The Interior Design Firm

She's a successful, innovative interior designer, and Pam Stanek, ASID, has proved in her 25 years in business that she's also extremely smart and savvy. She's not only the principal of her design firm, having her finger on all business and marketing aspects, but personally meets with a heavy load of satisfied clients on a daily basis. She confidently and efficiently leads the large design firm consisting of 12 other interior designers and an administrative staff of four.

Pam is creative in meeting other challenges. Because Omaha lacks a major design center, she developed a resource library for her designers.

IDF designers operate from their custom-built 14,500-square-foot design studio, which contains one of the Midwest's largest resource collections of furniture, lighting and accessories. Thousands of fabrics, wallpapers, carpets and tiles line the walls of the library. The remainder of the studio includes offices and showroom space.

Another secret of her success is her involvement with the industry's professional organization, the American Society of Interior Designers (ASID) and insists that all IDF designers become affiliated with the organization, as well as pass the industry's highest certification, the NCIDQ. "Doing these

things makes each of us more professional and keeps us current with what's happening in the design field," Pam says.

Her method of working with clients has led to repeat business and referrals. When a new client contacts the firm, a designer conducts an in-depth interview to learn about their design preferences. The designer visits a new client's home or office to see firsthand their current lifestyle choices.

"Television and the Internet have made our clients more willing to experiment on their own." Our clients, like everyone else's, are more knowledgeable," Pam says. "Many think they can complete the designs themselves, but they get into the process and get confused because of the many choices. That's when they call us. Mistakes can be costly when they involve the wrong style, scale or color."

Color is one element that Pam feels strongly about, which she attributes in part to Nebraska's long gray winters. "One of the first things you do with a client is decide on their color palette since it's such a personal choice," she says.

TOP
This model home is cozy enough to raise a young family in but is also filled with light and is open to its surroundings.
Photograph by Jeffrey Bebee

BOTTOM
Custom detail tiles and wood moldings create a warm and traditional elegance to this master bathroom. This remodel captures a traditional grace while embracing its modern amenities.
Photograph by Tom Kessler

FACING PAGE
No detail was overlooked in creating this grand space. Custom railing, molding, lighting and furniture pieces style this space for the most scrupulous visitor.
Photograph by Gary Gerding

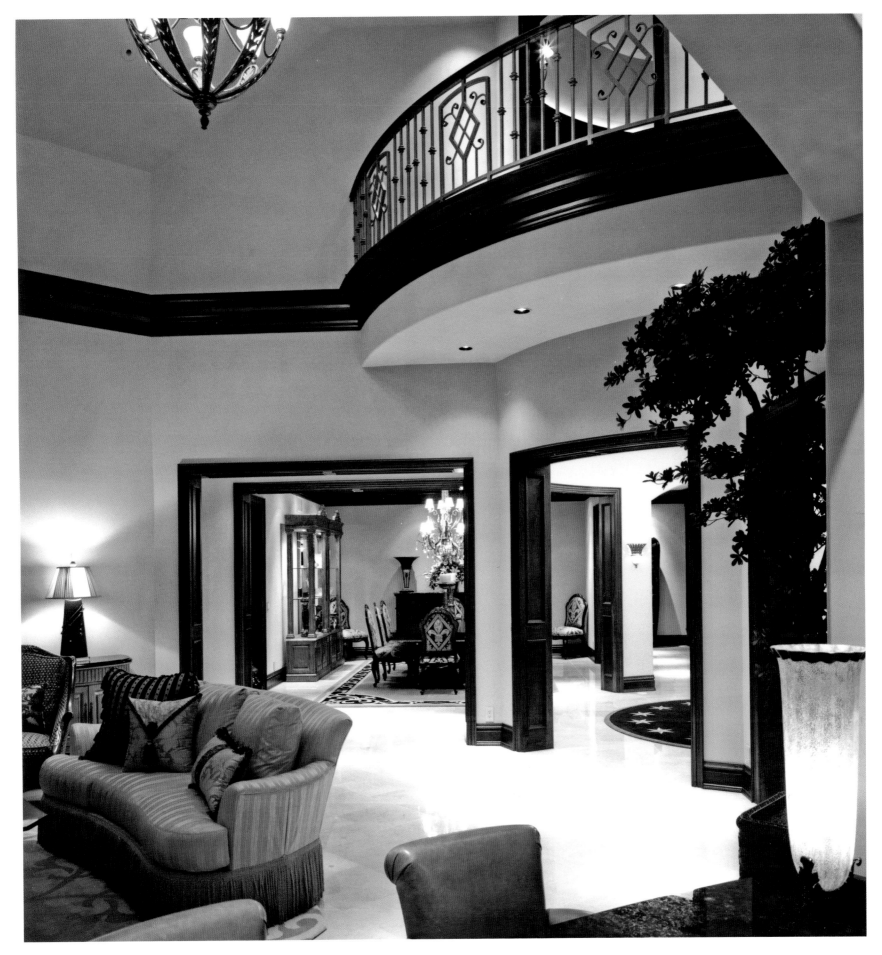

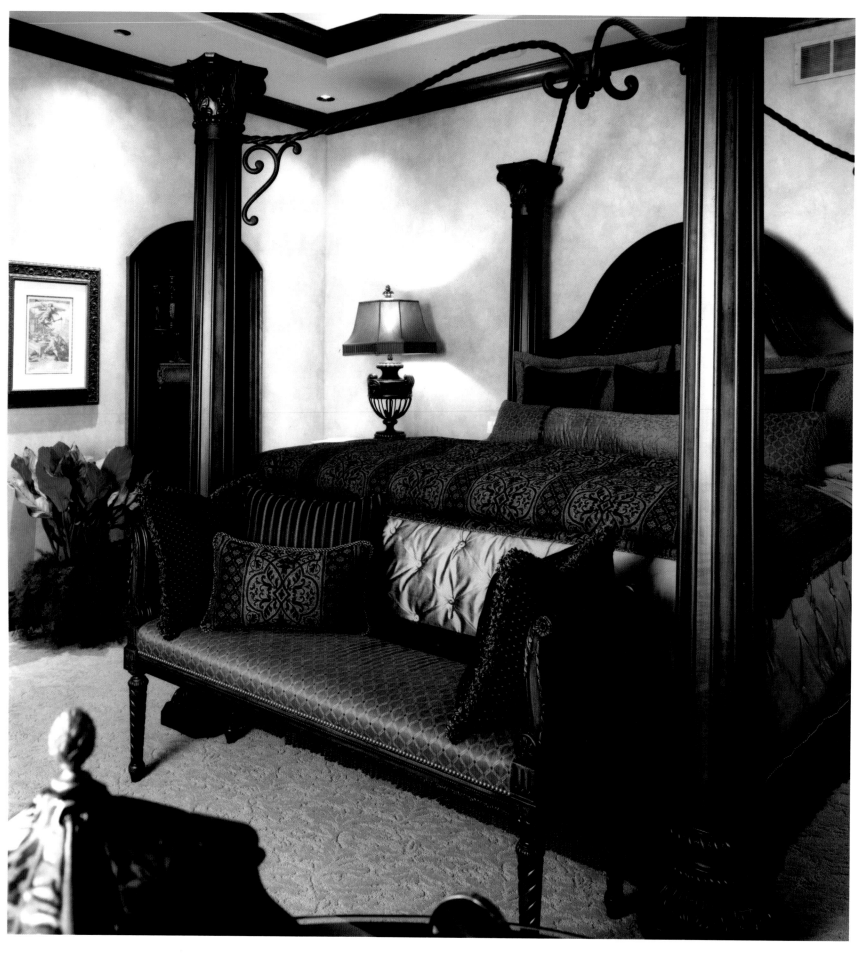

But no matter what projects a designer is working on, Pam stresses to her staff that their families should remain the most important component in their lives. "Family emergencies and important events come before work, which is unusual in today's work world," Pam says. Her concern offers another advantage. "It's the reason why the vast majority of my designers never leave," she says. Neither do clients.

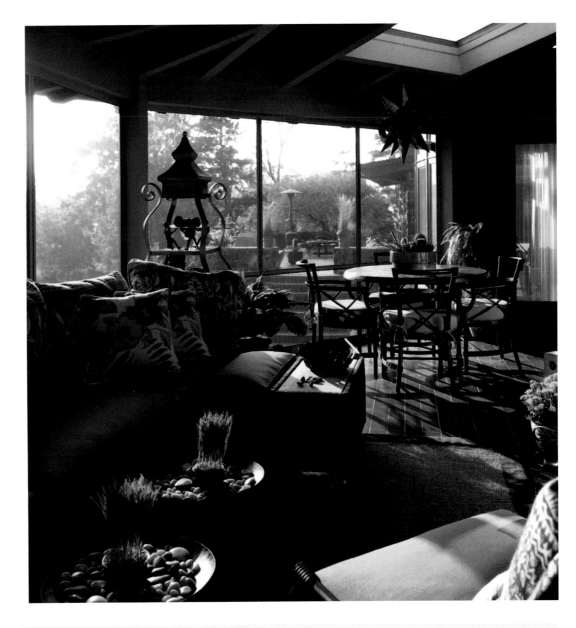

RIGHT
Willow limbs cover the beamed ceiling of this sun porch; the screened porch provides a sheltered outdoor living area well-suited for three-season entertaining.
Photograph by Gary Gerding

FACING PAGE
Masculine styling of furniture and molding combined with sumptuous fabrics in earth tones introduce a luxurious feel to the master bedroom grand estate.
Photograph by Gary Gerding

More about Pam...

OTHER IDF DESIGNERS:

Mary Carter, ASID; Anita Wiechman, ASID; Deb Munro, ASID; Julie Stanek, ASID; Callie LaScala, ASID; Robin Lindley, Allied Member ASID; Becky Jackson, ASID; Gwen Ahrens, ASID; Becki Wiechman, ASID; Christine Walker, ASID; Joyce Wimmer, ASID and Jennifer Chebatoris, Allied Member ASID.

ANY AWARDS OR SPECIAL RECOGNITION YOU WOULD LIKE MENTIONED?

IDF has been voted by the public and celebrated by *Omaha* magazine as "The Best of Omaha" in interior design for three years running—2004, 2005 and 2006. We've been a "Street of Dreams" winner several times and have received numerous ASID project awards.

WHAT PHILOSOPHY HAVE YOU STUCK WITH FOR YEARS THAT STILL WORKS FOR YOU TODAY?

That philosophy would be that the most successful projects require a hands-on involved approach from the beginning to end—from space planning with the architect to working with the contractors; all the while making decisions with and for the client. Knowing all the details, and understanding the complete project enables me to provide a unique solution for every client. My style usually includes classic details, clean lines and new ideas.

THE INTERIOR DESIGN FIRM
Pam Stanek, ASID
17110 Lakeside Hills Plaza
Omaha, NE 68130
402.334.8800
Fax 402.334.2641
www.idfomaha.com

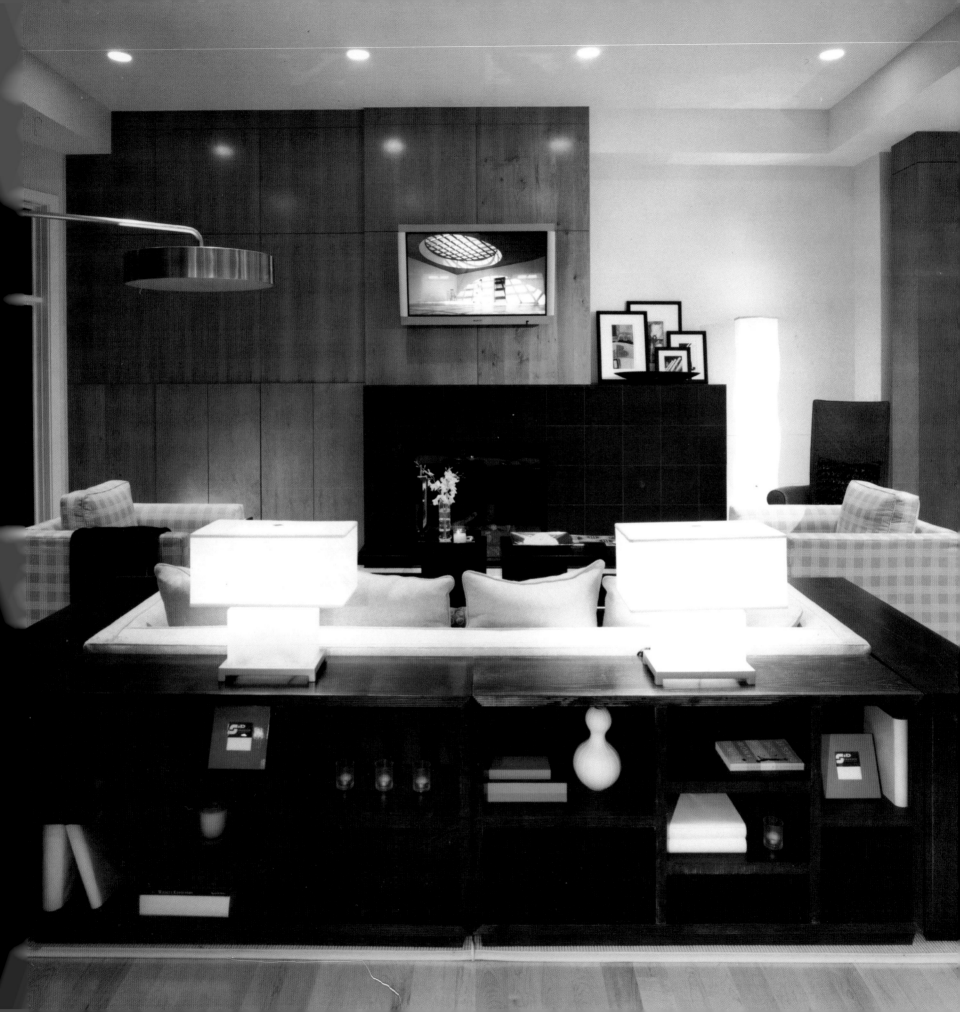

KIMBERLY SWANSON

Swanson Interior Design Group

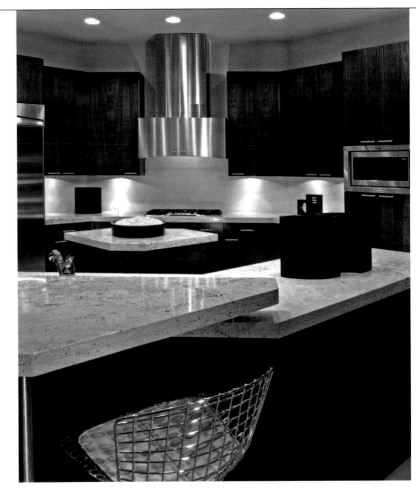

Whether it's the perfect vintage chair, or a refined architectural detail, the constant search for inspiration always leads to the next big thing. Clients credit Kimberly Ann Swanson, principal of Swanson Interior Design Group, for always being "in the know," with an eye for the finest of details. Creating interior environments that vary from restrained luxury to overwhelming comfort, she works with clients to find out what their dream environment is, and creates it. With a design team of eight based in the Midwest, Kimberly serves as design director on projects from coast to coast, with a second location in Palm Desert, California, originally founded to service Midwestern clients with second homes on the coast.

She credits her success to several factors, including her ability to find top artisans, custom fabricators, craftspeople, architects and builders, and design an entire house rather than just a single room. "We're known for new construction and major remodeling and for being able to do any type of design, whether modern (her favorite), traditional, or transitional. Her firm also continues to stay involved in commercial projects.

She listens well to her clients and recognizes their interests. "We pursue our clients' visions," she says. What more desire is a setting that encourages casual living and entertaining with specialized rooms for a home theater; kitchen/great room combination with the latest equipment and best

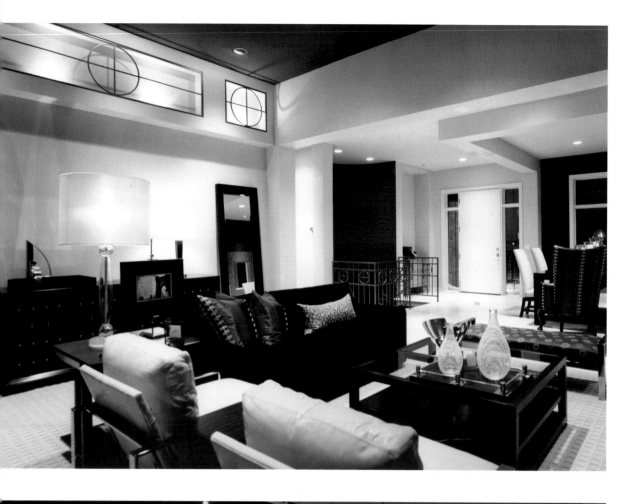

materials; command center to manage your household with the latest of technology.

And finally, she understands that different locations inspire different looks and needs. In the Midwest, the cold climate doesn't allow extended use of outdoor kitchens while her desert homeowners are following the trend toward bigger, better outfitted cooking stations. At the same time, she tries to expose her Midwest clients to new equipment, materials and color palettes that start on the coasts, she says.

Her professional membership in the American Society of Interior Designers (ASID) gives her an edge. It enables her opportunities for education, knowledge sharing and advocacy on advancing the interior design profession.

As her clientele keeps evolving, Kimberly's goal is to pursue further projects in new areas of the country. A recent project in Washington, D.C. inspired her to research the area's preference for traditional woods and transitional furnishings. No matter where she's maneuvering or who she's collaborating with, her firm's strategy is simple: "We believe your home should be an experience."

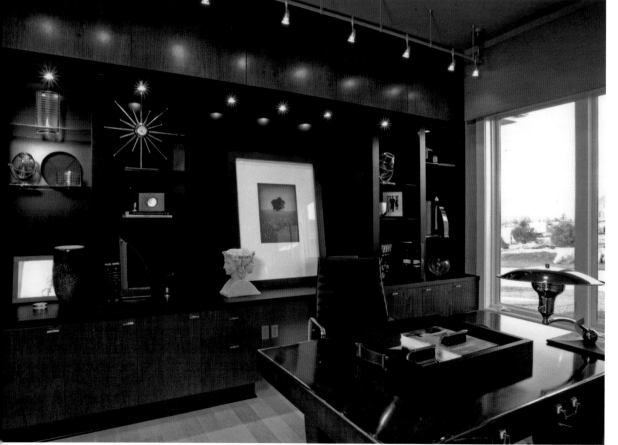

TOP
Details, a study of wood, metal and light motifs create a sleek and smart interior.
Photograph by Paul J. Brokering, AIA

BOTTOM
Dark walnut panels and black veneer are dramatically highlighted by architectural lighting in this functional office and den.
Photograph by Paul J. Brokering, AIA

FACING PAGE
Clean minimalist finishes of natural maple flooring and cherry columns, vividly contrasted by pop art colors, draws you in to this modern home.
Photograph by Paul J. Brokering, AIA

More about Kimberly …

WHAT SEPARATES YOU FROM YOUR COMPETITION?

My process, which is to listen, visualize, create and produce.

DESCRIBE YOUR STYLE OR DESIGN PREFERENCES.

Transitional and modern.

IS THERE ANYTHING YOU WANT TO MENTION ABOUT YOURSELF OR YOUR BUSINESS?

We design luxury, award-winning interiors for every lifestyle.

WHAT PERSONAL INDULGENCE DO YOU SPEND THE MOST MONEY ON?

Fashion, particularly shoes and bags.

HOW MANY DO YOU EMPLOY?

Four other designers and a support staff of three.

SWANSON INTERIOR DESIGN GROUP
Kimberly Ann Swanson, ASID
5700 Old Cheney Road
Lincoln, NE 68516
402.434.5350
www.swansoninteriors.com

JOY TRIBOUT

Joy Tribout Interior Design

RIGHT
Wall décor and coffered ceilings make this narrow dining space seem spacious. The unusual light fixture draws focus upward.
Photograph by Bob Greenspan Photography

LEFT
The multiple light sources create a bright yet welcoming game room retreat.
Photograph by Bob Greenspan Photography

Joy Tribout has an intuitive sense when it comes to working with her clients—she can detect a new client's vision from the photographs they love, visiting their home, asking questions and careful listening. "The whole objective of designing the interior of a family's home is to make it beautiful through their eyes. Everyone has different likes. Being able to judge someone's preferences and dreams is just as important as a designer's ability to implement the design," she says.

A designer for 24 years, Joy waited to start her business until her children were in school.

With her son Torre's advice, Joy was able to integrate business strategies into her design. Together they developed Caroline Cole Inc., a pillow manufacturing company that emerged from the designs Joy was already doing for individual clients.

With professional seamstresses and upholsterers on staff, Joy maintains extremely high production standards. An 8,000-square-foot manufacturing facility located Belleville, Illinois allows Joy complete command of nearly every aspect of design and production. With daughter, Tammy Caruso at her design side and her son running

Caroline Cole, family has developed into an important aspect of her business.

It's not uncommon for a bond to form when working with a homeowner. Joy considers most of her former clients good friends. Ultimately the duo, designer and homeowner, build houses into homes together. Beginning with a sit down discussion, Joy starts to understand personality of the client. The process breaks ground with questions, shared portfolios and open ears. The needs and desires of the client are integrated from the ground up. Joy is involved not only in the wall color and the fabric choices, but in every last detail—from the marble slab flooring to the decorative hinges and door knockers.

Joy loves to incorporate animal prints into her designs. The unexpected bold animal patterns and furs may grace the edges of pop culture, but Joy's wild kingdom influence rises above the fad and settles into its own identity of elegance and timelessness. Whether it's floor to ceiling zebra window treatments, a bit of fur tucked within the lining of a centerpiece, or a dramatic antler chandelier, Joy's choice of fabrics and accessories induce a warm tactile richness clients adore.

The secret to Joy's success is her ability to adjust designs for each client's taste. "I can work in a French Style, be eclectic or even contemporary," she says. Some of her favorite trademark touches are to use green as a base color or accent. Joy reminisces, "Green makes a room come alive, no matter what other colors are used."

TOP
When grouping many accessories together, it is important to stick to a few core colors and shapes.
Photograph by Bob Greenspan Photography

BOTTOM
This grand living room is a calm quiet blend of whites and taupes, complemented by the antiqued silver accessories.
Photograph by Bob Greenspan Photography

FACING PAGE
When creating symmetry, we always try to create a pivot point. In this case it is the centrally placed coffee table, from which every other element radiates out.
Photograph by Bob Greenspan Photography

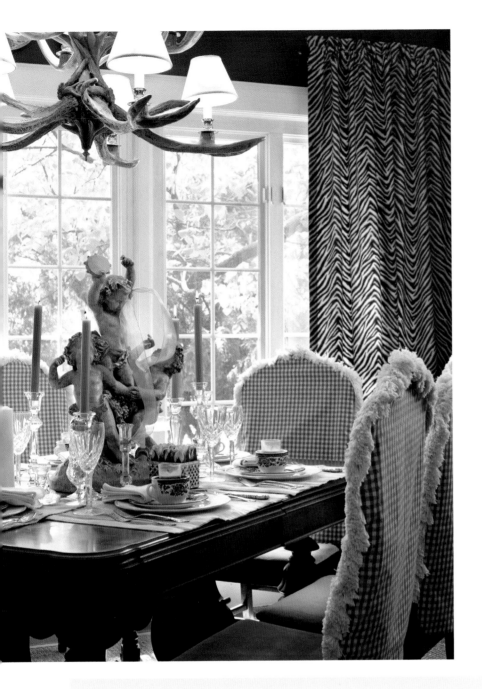

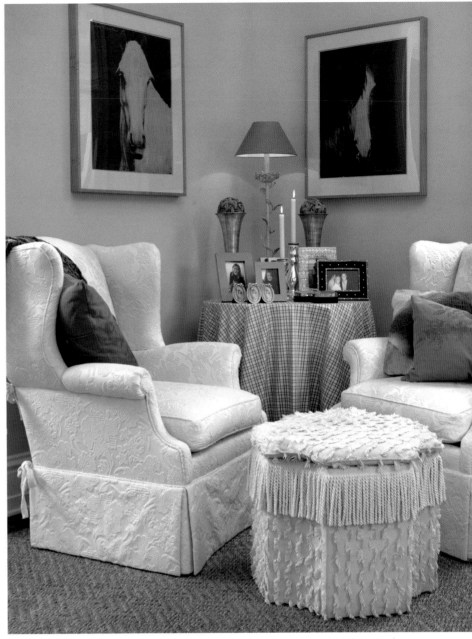

More about Joy ...

IS THERE ANYTHING ELSE SPECIAL ABOUT YOUR BUSINESS?

My daughter is a designer with me; we work well together. She tends to like using a bit more in an interior, and I like using a bit less, so we work well together.

WHAT COLOR BEST DESCRIBES YOU?

Green, which makes me very happy.

WHAT SETS YOU APART FROM YOUR COMPETITION?

I am hands on for all jobs and complete each project from start to finish.

WHY ARE YOU SO EXCITED ABOUT BEING IN *SPECTACULAR HOMES*?

I love hardcover design books; I buy them all the time and now I'll be in one!

JOY TRIBOUT INTERIOR DESIGN
Joy Tribout
711 South Illinois Street
Belleville, IL 62220
618.233.0600

8139 Maryland Avenue
Clayton, MO 63105
314.721.0670
www.joytribout.com

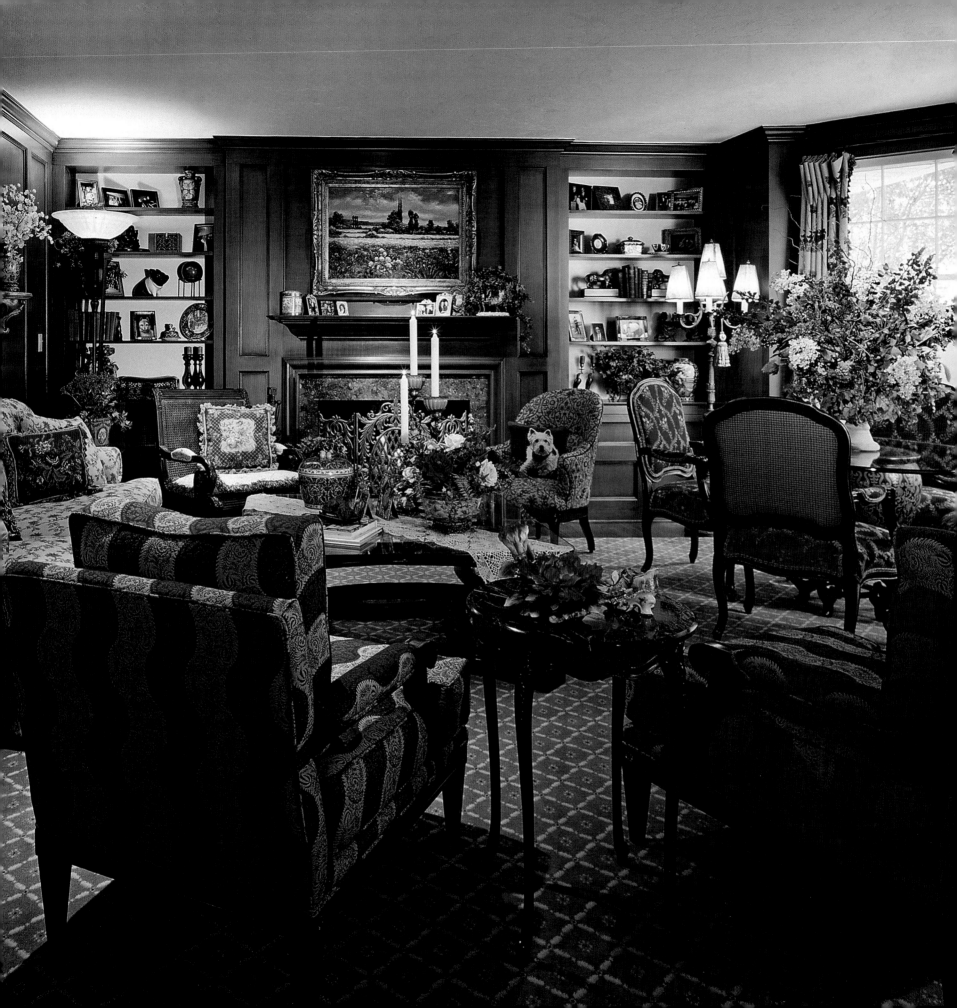

KATHRYN VAUGHT

Kathryn Vaught Interiors

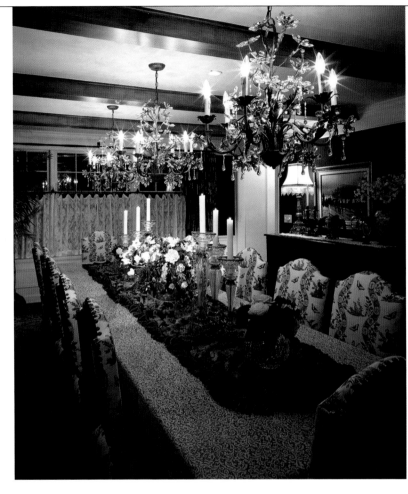

Kathryn Vaught, ASID, knew she wanted a career in the arts field, but it took a few years for her to decide exactly what it would be. She started in advertising, doing detailed pencil drawings that had a photographic quality, but felt divinely inspired to switch to interior design.

In her first design job, she rendered watercolor sketches of what rooms should look like for clients and realized she could design the rooms as well. She went back to design school to hone her skills while she continued working for a well known designer and eventually decided to open her own firm. Twenty-three years later, Kathryn continues to design from a studio in her home, contracting out work to a regular stable of talented craftsmen, including her husband, Tom, an artisan himself, who works in both decorative iron and custom furniture.

Kathryn especially enjoys working with clients from the beginning of a remodel or building of a new home. "It's an opportunity for me to design custom millwork with unique design features, such as architectural antiques, cast iron panels, or unusual finishes," Kathryn says. She strives to help clients discover their own personal design style; collecting an extensive library of photos from books and magazines to determine their personal design flavor. "I have, for example, a file of just Tuscany kitchens, files of every kind of fireplace design and others with a Southern

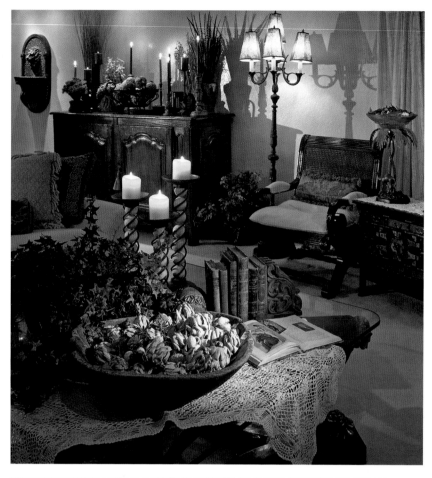

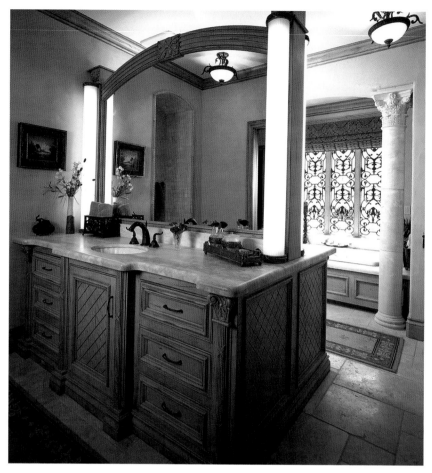

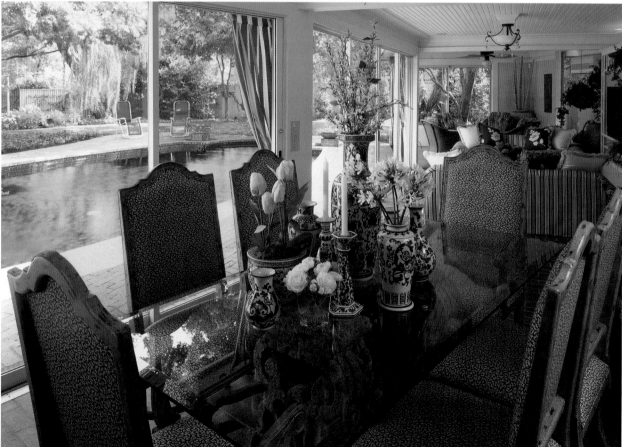

TOP LEFT
Warm, inviting and with an air of romance are the qualities Kathryn achieved using an array of dried botanicals and the circa 1800 Louis XV buffet from southwest France.
Photograph by Reyndell Stockman

TOP RIGHT
Kathryn designed a duel open vanity with integrated lighting and hidden outlets. Limestone tile and columns, decorative iron window panels and sand finishes create subtle texture.
Photograph by Reyndell Stockman

BOTTOM
This sun-kissed cabana was filled with an array of recovered furniture from a previous home. Splashes of cobalt blue complement the all-tile pool.
Photograph by Reyndell Stockman

FACING PAGE
A feeling of soft, luxurious, calm was the intention for this master suite. Kathryn designed the bed and end table, which her husband, Tom, built incorporating decorative iron.
Photograph by David Cobb

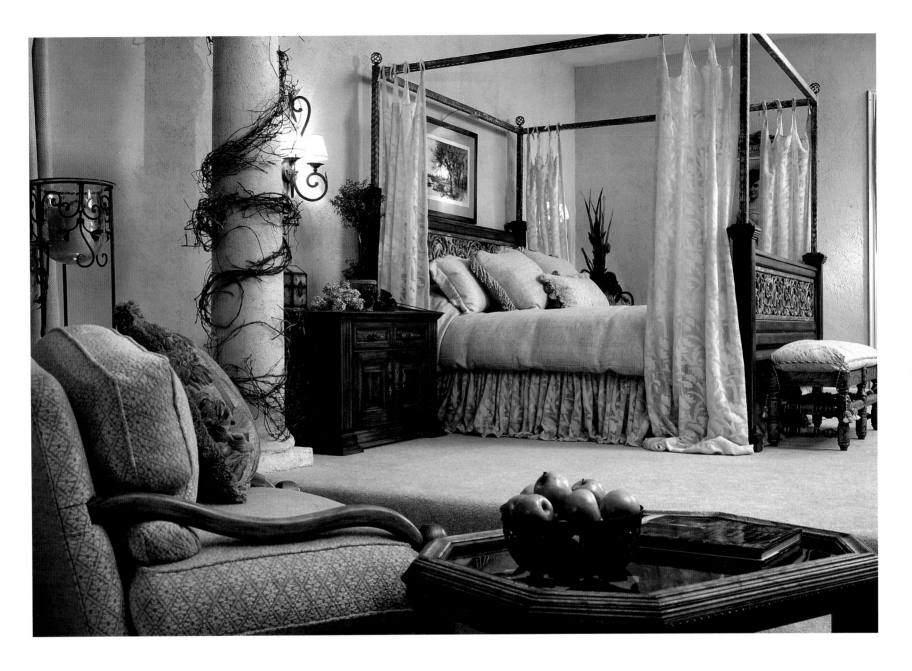

What's also greatly helped her clients envision the results she plans for them is her ability to sketch, a talent she never gave up.

"I love working with color!" she says. "For clients that are opinionated on color, my job is made easy. For those who aren't so sure, I try and help their selections to be timeless and not trendy. I will usually direct them toward a more neutral color palette on the big ticket items, so that they can more easily change out accent pieces such as pillows, artwork, and rugs as their tastes evolve. I place a large emphasis on visual weight and lighting in a space. My sketches help both my clients and me to determine what might be necessary to achieve a sense of balance in a room. I try to give each room a purpose. I don't like spaces that aren't used. I strive to reflect my clients' personalities, usually to be comfortable and inviting, not pretentious."

Kathryn also believes that traditional design portrays a richness in elements that contribute to a room, demanding high-quality craftsmanship. She has been able to find talented craftspeople to meet her clients' high expectations in her own backyard of Oklahoma City. "We're able to provide a wonderful quality of artisanship in custom furniture, cabinetry and finishes. I find that people in the Midwest spend more time in their home because it's many times too hot or cold outdoors, and therefore the quality of craftsmanship is even more expected and appreciated here," she says.

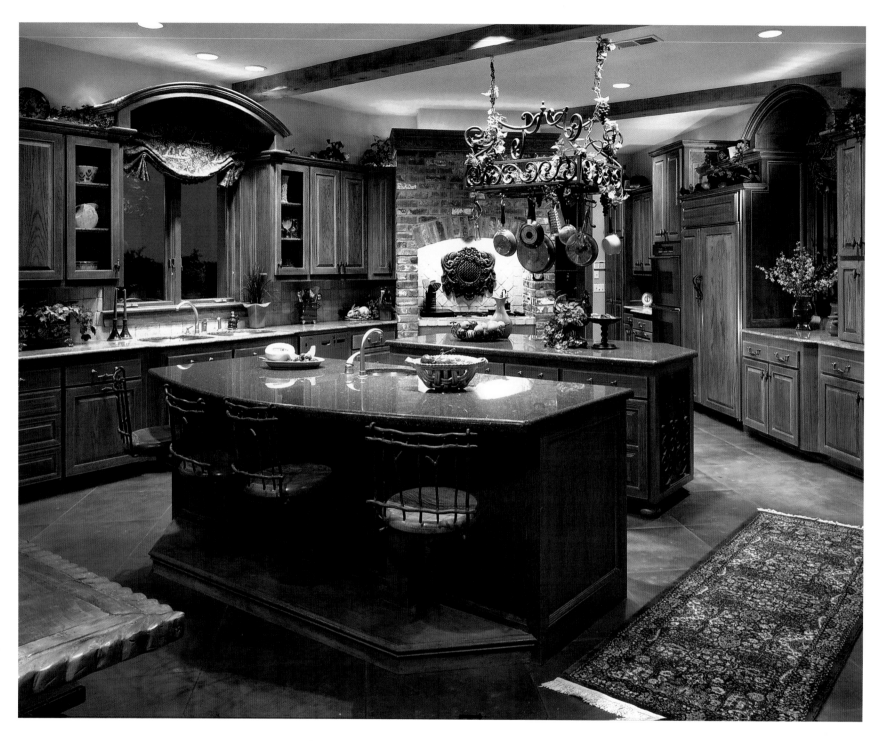

Kathryn and Tom's own home is located in historic Nichols Hills. They have raised their traditional ceiling, added beams, wall sconces, incorporated an antique carving in their mantel, and completed extensive remodeling through the years. "Our home has evolved like so many. My husband is responsible for building most everything, other than the antiques, and I've contributed with collecting objects I love," she says.

Although Kathryn describes herself as a workaholic, she says she has recently learned to pick and choose when jobs are the right fit both for her and potential clients. She has also made time for periodic lunches with girlfriends, a monthly dinner club with her gal pals, and daily walks with her two shelties, Lucy and Betsy.

ABOVE
This kitchen is truly the hub of the home. Equipped with two dishwashers and swivel out seating, it offers an open invitation to have a cup of coffee and stay a while.
Photograph by Reyndell Stockman

FACING PAGE
Antique ironwork was incorporated into the recessed back-lit shelving. Textures using a sand wall finish, chenilles and sisal shades create an inviting space.
Photograph by Reyndell Stockman

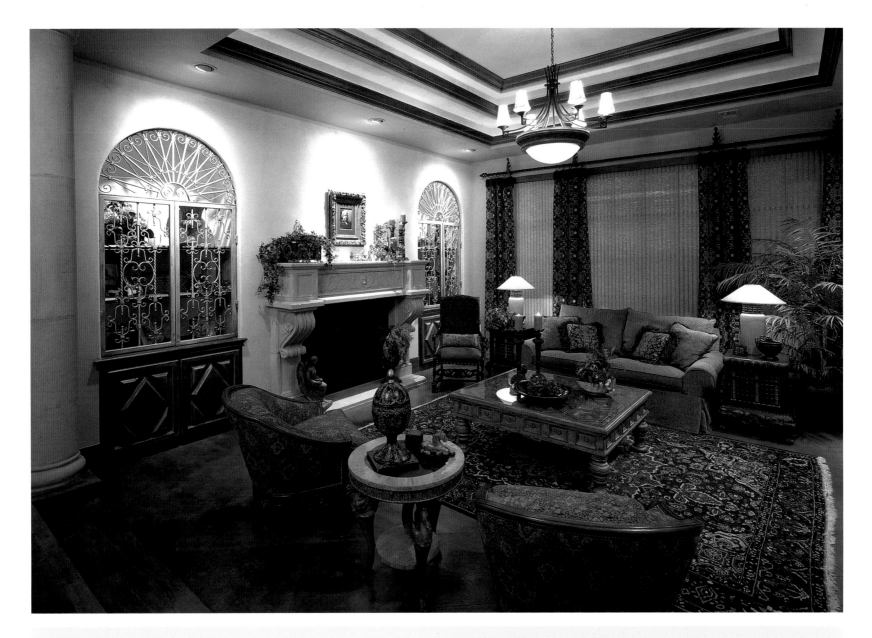

More about Kathryn...

WHAT SEPARATES YOU FROM YOUR COMPETITION?

I offer on sight quick sketches to help clients visualize what I have in mind. I truly strive to establish the style of my clients and not impose my own personal taste on them.

ANYTHING YOU'D LIKE TO MENTION ABOUT YOURSELF OR YOUR BUSINESS?

I have to say God has truly led me into this field and it's been entirely rewarding. Also, my husband, Tom, has been a big part of much of my life. He has built a lot of my design and custom furniture. I have been so blessed over the years with many of my clients becoming lifelong friends.

WHAT IS THE BEST PART OF BEING AN INTERIOR DESIGNER?

Every day is different from the next, with a uniqueness in each individual design project. I meet with clients to help them envision their style through pictures, sketches, samples, selection of materials, develop a proposal and then overseeing the entire process of a master plan. I'm thankful to have worked on three and four homes for various clients, and have to assume they consider it an enjoyable experience. I feel I'm pretty easy to work with.

KATHRYN VAUGHT INTERIORS
Kathryn Vaught
1807 Guilford Lane
Oklahoma City, OK 73120
405.843.1410
www.kathrynvaught.com

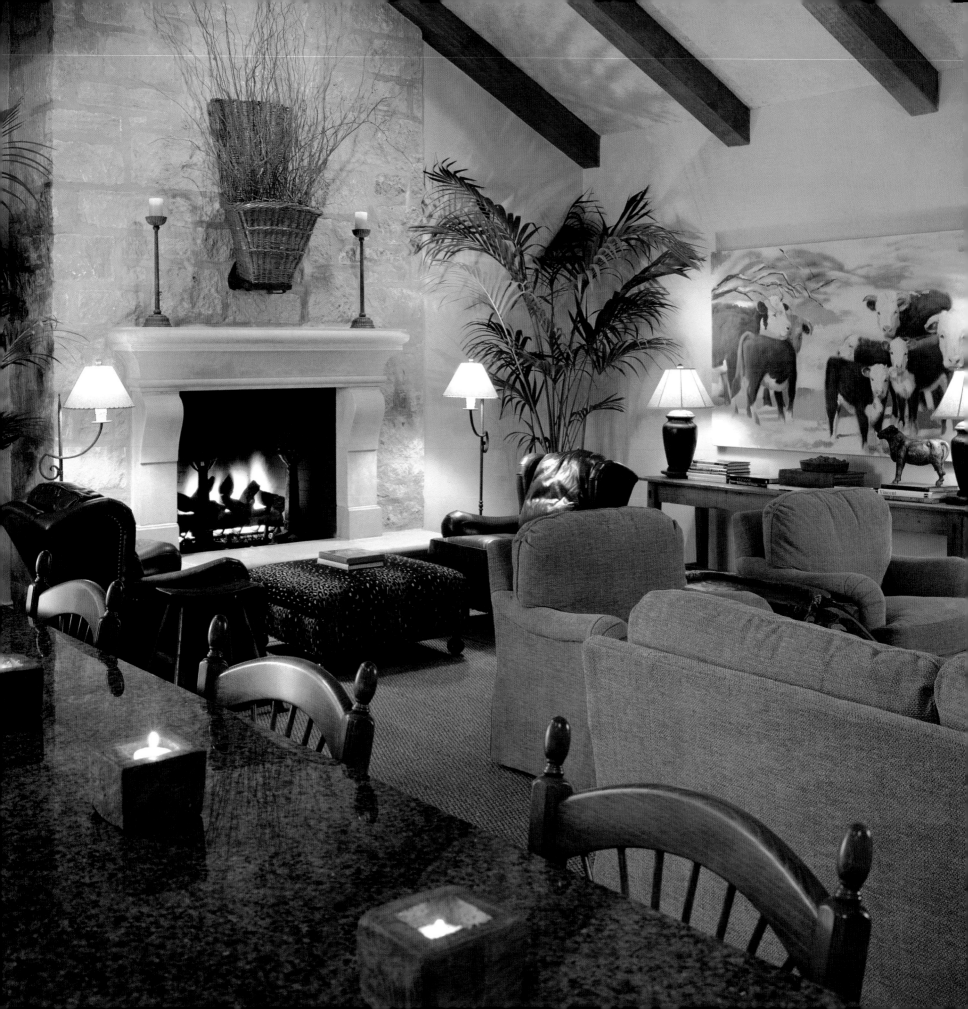

PAT WORMHOUDT & LIZANNE GUTHRIE

Design Studio, Ltd.

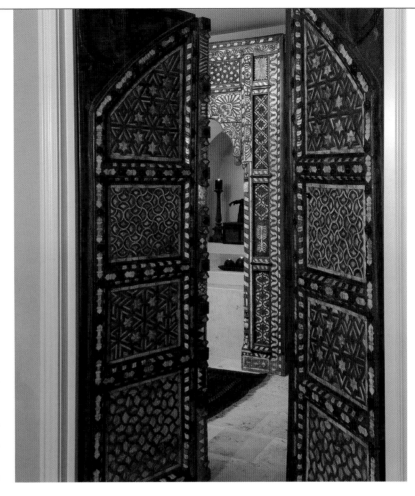

Creating soothing and harmonious environments for their clients is the greatest reward for the mother-daughter design team of Pat Wormhoudt and Lizanne Guthrie. "Our environment has such an impact on our attitude and emotions—by helping our clients realize their ideal surroundings we are doing our small part to make their lives better and more enjoyable," they explain.

Both designers agree that the essential elements to creating a restful atmosphere are symmetry, comfort and simplicity. "When a room has many focal points it becomes too talkative and you lose the peaceful quality," they say. This design team often places as much emphasis on what is eliminated

from a room as what is added. They avoid anything that is overdone or trendy—to them less is best.

Pat has worked as a designer since 1965. She opened her own firm, Design Studio, Ltd., in 1982. Daughter Lizanne, came on board in 1998 and both love exchanging design ideas with Pat's sister, Karen Marcus, a designer in Kansas City (see page 63).

As a long-time professional, Pat has learned that one of the most important strengths a designer brings to a project is the ability to envision the finished product. Although she acknowledges that the design business has

changed through the years, she believes that clients still appreciate the fact that a designer provides vast knowledge of the resources available, their quality, and the contribution each ingredient makes to the whole.

Both Pat and Lizanne love working in Wichita because of the freedom of styles. "Here we can use and mix styles ranging from Southwestern to Traditional, Contemporary, Country French, Tuscan, and even rustic Asian and have them all feel appropriate and at home," the partners say.

Despite this range in styles, the interiors this team creates all share some similarities. They all have a casually elegant, warm and inviting feel. "We believe strongly that including antique wood pieces adds soul and a sense of permanence to any room and the hunt for these one-of-a kind pieces is so fun and rewarding," they say.

LEFT
This charming Country French breakfast room features an antique wine tasting table and a built-in banquet with leather seat and fabric back.
Photograph by Pat Wherritt

FACING PAGE
Soothing neutrals and textures complement the beautiful, antique Italian doors employed as a headboard. The designers used large chests flanking the bed to properly balance the scale of the large doors.
Photograph by Pat Wherritt

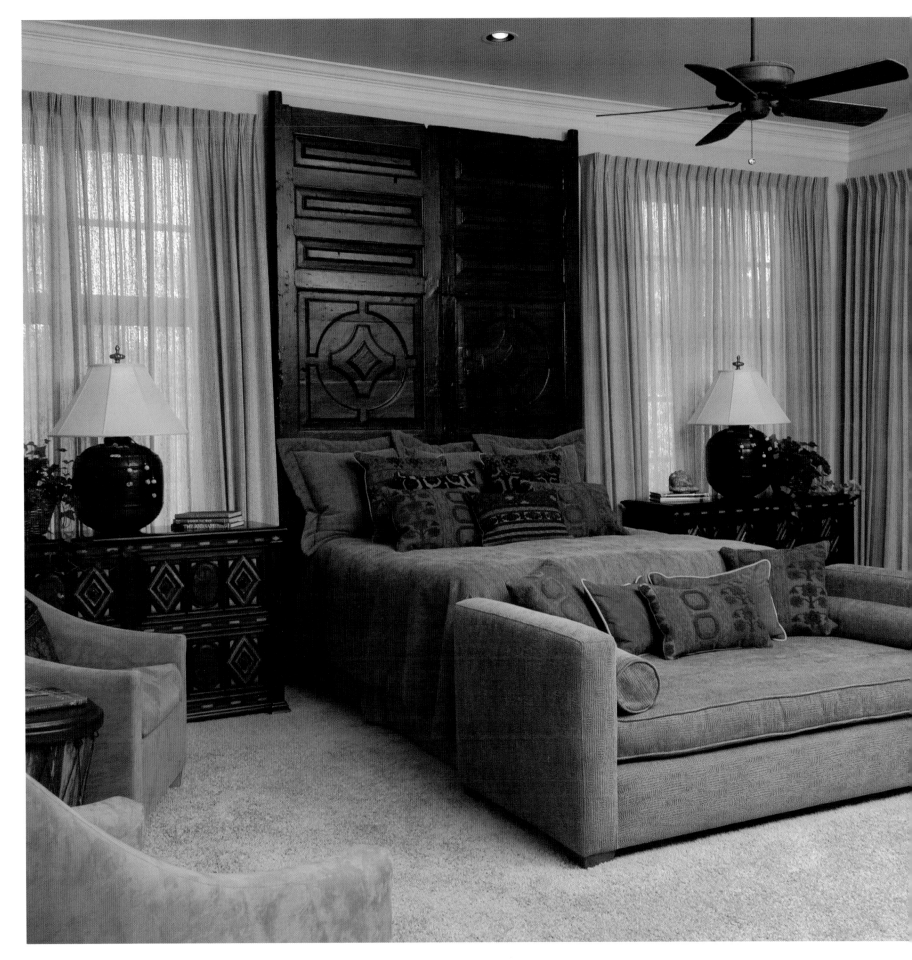

ABOVE
In this dramatic living room, the designers used a paprika linen velvet on a pair of chairs and an antique French sofa. This fabric also became the inspiration for the wall color. The entire room is grounded and enriched by the black, geometrically patterned rug.
Photograph by Pat Wherritt

FACING PAGE
This antique ebonized bed, inlayed with mother-of-pearl was brought to Mexico from Austria by Maximillian, emperor of Mexico. It made its way into the designer's bedroom by way of San Antonio.
Photograph by Linda Robinson

Some purchases are too special to let go of and end up in their own homes. Pat's bed, for instance, once belonged to Maximillian, the Austrian-born emperor of Mexico.

Pat and Lizanne also love the interest and richness that comes from mixing quality pieces from all over the world with beautiful rugs and textiles. It is important to them that their clients' tastes and loves be reflected in their interiors. "A room should give you insight into the person who lives there; otherwise the effect is sterile and uninviting," they say. They also feel that the balance of light can make or break any room.

Pat credits her mother with shaping her aesthetic sensibilities. "We moved many times when I was growing up because of my father's job with the Santa Fe Railroad, yet every one of those homes was pretty." Professionally she acknowledges John Coultis, a well known Wichita designer, with teaching her much about scale, color and antiques.

For Lizanne, her mother Pat and aunt Karen are her inspiration. "I can remember spending time at my aunt's home as a child and just being in awe of how beautiful and well thought out every room was. I am truly blessed to be working with my mother. She is a fabulous designer who always puts the client and the finished product first. She has trained my eye and honed my skills all the while showing the greatest patience and love," she says.

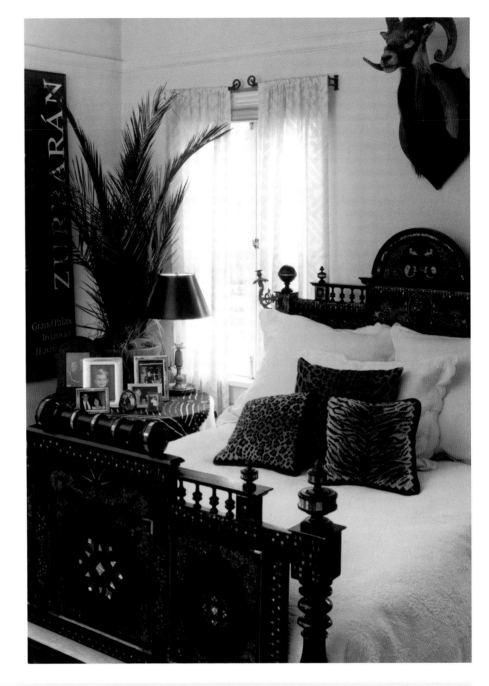

More about Pat & Lizanne…

For Pat it's the occasional irresistible antique. It could be a coffer, unique chair, beautiful painting or santo, or fabulous chest of drawers. For Lizanne, who has two young children in private school, it's the occasional interesting estate sale find, especially art.

Most people don't know that the bed Pat sleeps in once belonged to Maximillian, the Austrian-born emperor of Mexico.

A client once told us that the look we created was the look they had always hoped for, but didn't now how to achieve and that their home was now a haven for them, enabling them to enjoy life more. If you can do that for someone what more could you ask? We also had a different client tell us once that those who say money can't buy happiness don't know where to shop—that is basically the same kind of compliment.

DESIGN STUDIO, LTD.
Pat Wormhoudt
Lizanne Guthrie
2820 East Central Avenue
Wichita, KS 67214
316.682.6612

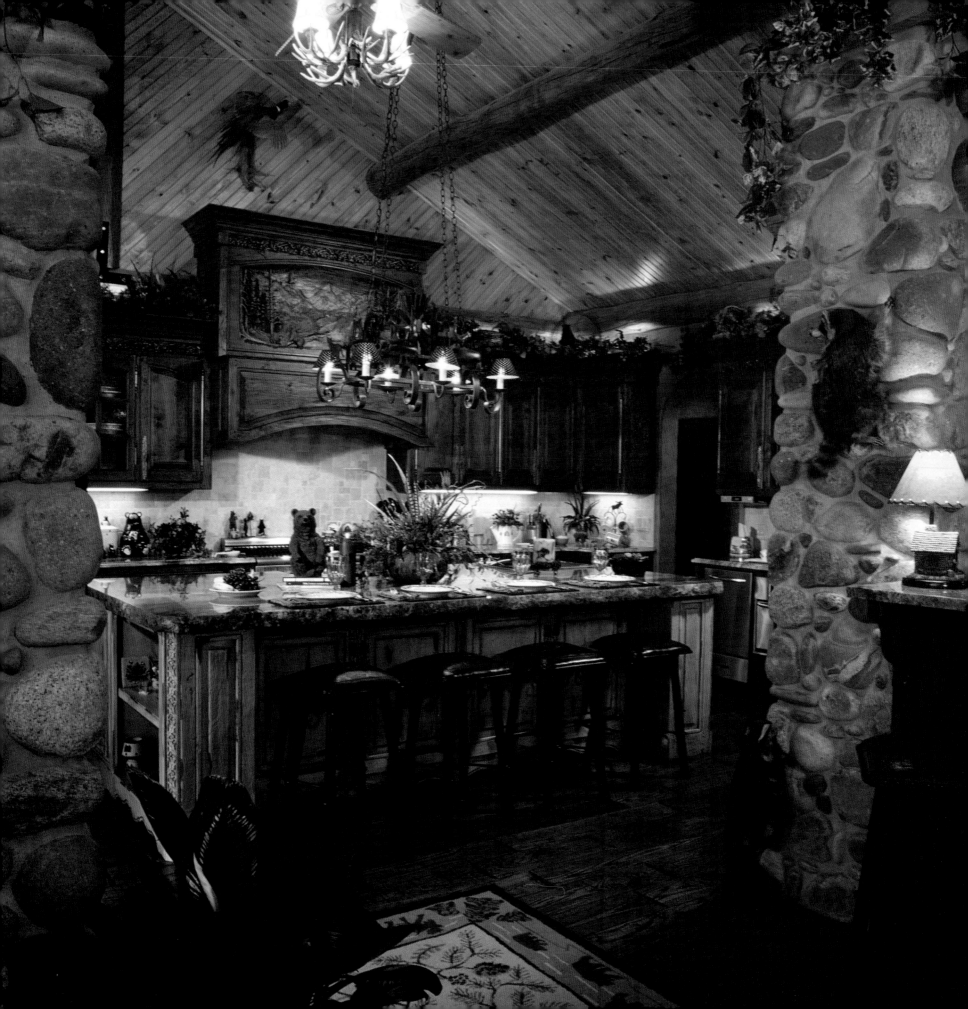

DEBBIE ZOLLER

Zoller Designs & Antiques, Inc.

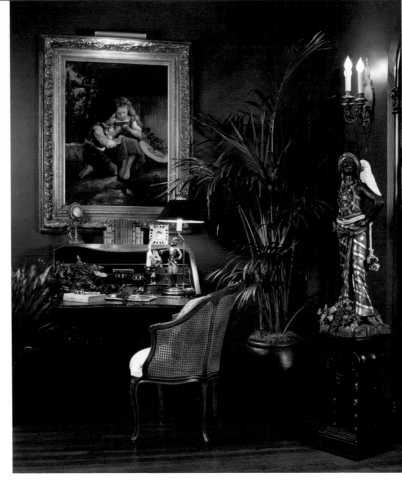

RIGHT
Deep hued walls welcome visitors into the McBirney mansion's formal living room.
Photograph by Rick Stiller

LEFT
To give this kitchen its rustic feel, Debbie chose only natural elements such as hand-chipped granite, reclaimed wood for the cabinetry, river rock stone pillars and leather upholstery.
Photograph by Rick Stiller

The best designers create settings for their clients that represent the homeowner's personal tastes, needs and preferences. Debbie Zoller, founder of Zoller Designs & Antiques, Inc., has been able to satisfy this requirement. The company she started 18 years ago in Tulsa, Oklahoma, is rooted firmly in helping a clients achieve a classic, timeless design that is customized to their idiosyncrasies and approach to life, not hers. Whether the design is French, Italian, Rustic, Contemporary, or Eclectic, it is timeless and a reflection of the homeowners. This, Debbie believes, is key to a brilliant design.

Picture rooms with elaborate custom draperies that sweep to the floor and draw the eye up to the ceiling, deep plush seating with overstuffed cushions and rolled arms that an occupant never wants to vacate, colorful patterned rugs with the look of an antique even if they were woven yesterday, richly colored walls, and gleaming hardwood floors.

Creating these types of spaces requires time and passion, two characteristics Debbie eagerly offers her clients. She hunts for unusual furnishings and accessories by traveling to Europe several times a year and particularly to France and occasionally Italy. She visits the High Point, North Carolina, furniture market twice a year and regularly scouts Dallas' and Chicago's furniture showrooms. She also actively participates in her trade association, the American Society of Interior Designers, and attends its annual meeting to stay abreast of new trends in home furnishings, materials and colors.

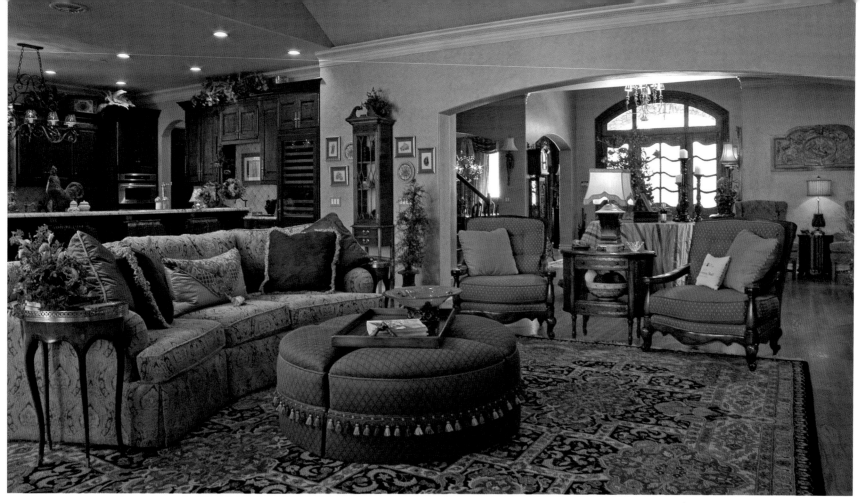

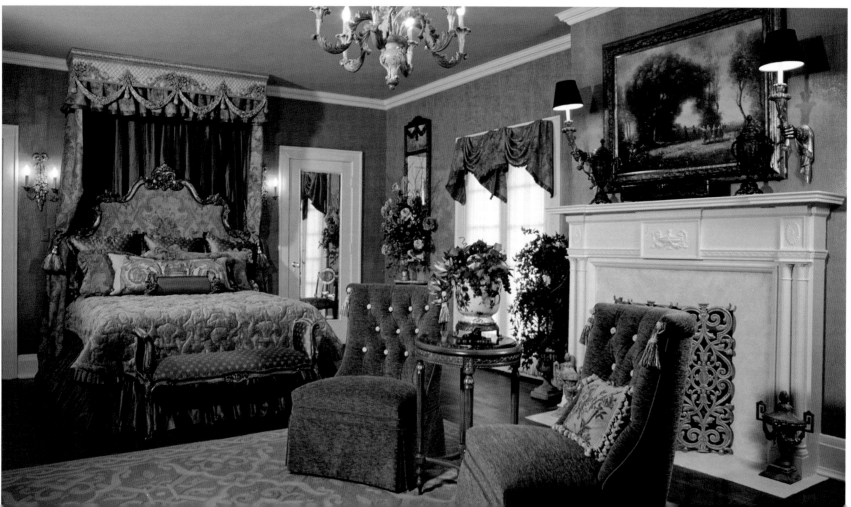

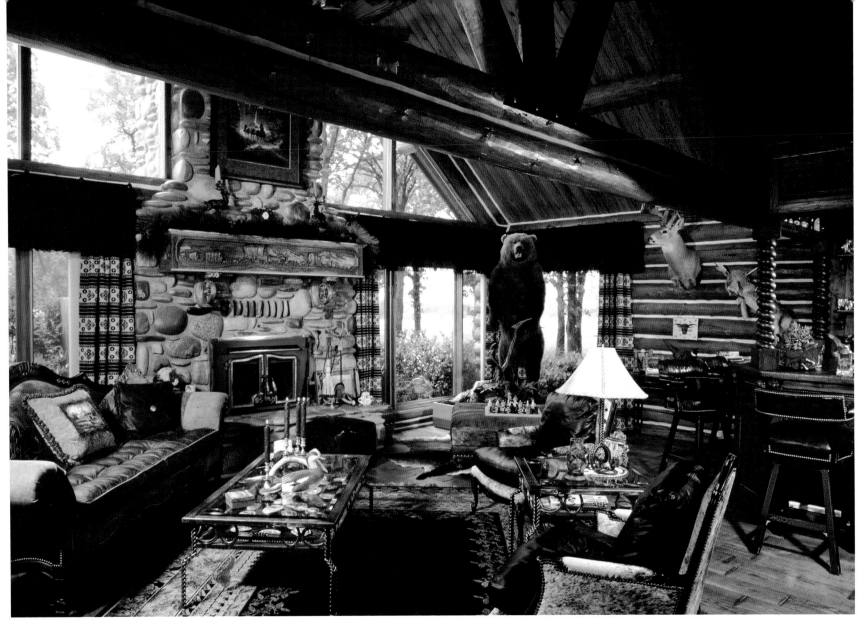

Now, for instance, she says she's on a green-yellow kick because she thinks that hue is particularly soothing and inviting. "It makes a very nice backdrop for any space," she explains.

Becoming an interior designer was not Debbie's initial career choice but one that she wholeheartedly embraced after working in the medical field for seven years. She knew she wanted to pursue a different profession, and she had long been interested in design and even decorated her own home. She tested the waters by taking classes in the history of interior design. She went on to earn a degree, secured an internship with a prestigious mentor and company, and eventually opened her own firm out of the proverbial spare bedroom.

Within a few years, she was so busy with clients that she opened an office and showroom, which remain in their current location on 15th Street in the historic Cherry Street area of Tulsa, which is filled with antiques and design shops. The shop attracts passersby who like the room vignettes they see within. Many clients hire her, in fact, she says because of her retail space. Two full-time staff members Jessica Mitchell, Allied Member ASID, and Lindsay Parker, Allied Member ASID, accompanied by one part-time staff member help her manage the company's busy workload.

Although the overall taste preference in Tulsa still veers toward the very traditional, Debbie has educated clients to incorporate some contemporary

ABOVE
Serving as a trophy room for the client's many excursions, this saloon features hand-tooled leather, an alligator skin bar top, and hair-on-hide upholstery.
Photograph by Rick Stiller

FACING PAGE TOP
This custom home focuses on entertaining, Debbie and her associates designed the great room as a gathering space for any party. The four-piece ottoman serves as extra seating for guests and the large center bar encourages interaction between guests and chef.
Photograph by Rick Stiller

FACING PAGE BOTTOM
This master bedroom showcases lavishly textured fabrics and an intricately hand-carved canopy.
Photograph by Rick Stiller

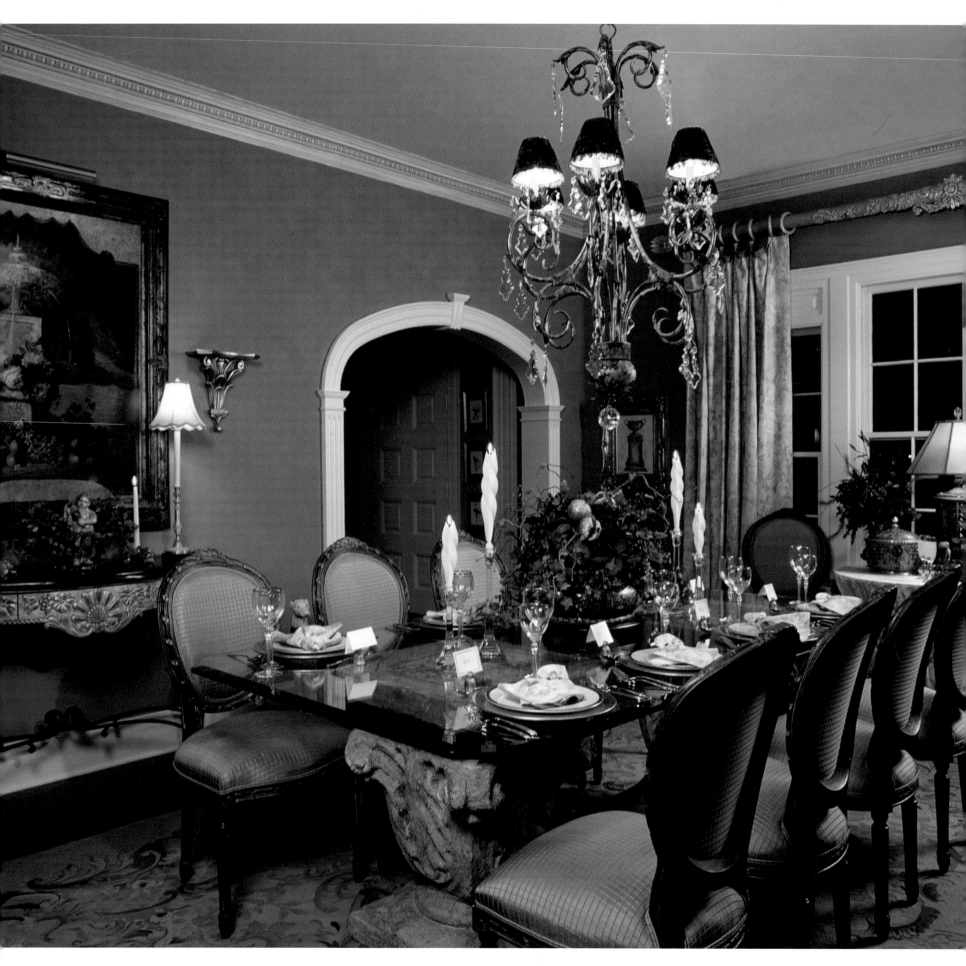

touches and pieces into their rooms, which helps create a more distinct, personal style. "I want everyone's home to be very different. Their home is their personal space. It's more interesting for them and it's also more interesting for me to do something entirely different for each client," Debbie says.

Another favorite aspect of her business, she says, is the personal relationships that generally evolve as she helps her clients turn their visions and goals into a reality. But Debbie also relishes how the industry's increasing competitiveness, as well as home owners' greater education in doing their homework, have spurred her to do a better job of helping them understand the advantages of hiring a designer. "The biggest service we can offer is to keep them from making costly mistakes," she says.

RIGHT
The expansive ceilings and vast space of this apartment complex lobby in Memphis offered no challenge for Debbie. Precise placement of furniture and accessories give the lobby a formal yet inviting ambiance.
Photograph by Rick Stiller

FACING PAGE
Debbie balances the cold appearance of the glass top and stone pedestal table with a warm color palette, refined fabrics and a delicate chandelier.
Photograph by Rick Stiller

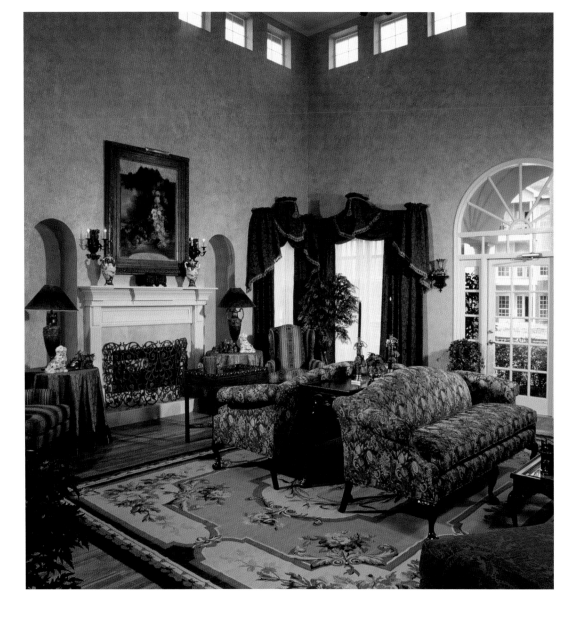

More about Debbie...

WHAT SEPARATES YOU FROM YOUR COMPETITION?

We try and get very involved with our clients. We make friends with them, and even after a project is over we stay friends because we were so involved with them and their families. About 85 percent of our jobs are with homeowners/families; a few jobs are commercial, which we also do well.

WHAT IS THE HIGHEST COMPLIMENT YOU'VE RECEIVED PROFESSIONALLY?

One client was so cute. He called and said, "You've Zollerized my house." It made us feel special that he put us in such a "prestigious" category.

IS THERE ANYTHING YOU WOULD LIKE TO MENTION ABOUT YOURSELF OR YOUR BUSINESS?

It makes a big difference if you enjoy what you do. We love our work and enjoy working with our clients. We enjoy helping them from conceptual planning to simply locating that unique accessory to finish off that special room.

ZOLLER DESIGNS & ANTIQUES, INC.
Debbie Zoller
1603 East 15th Street
Tulsa, OK 74120
918.583.1966
www.zollerdesigns.com

THE PUBLISHING TEAM

Panache Partners, LLC is in the business of creating spectacular publications for discerning readers. The company's hard cover division specializes in the development and production of upscale coffee-table books showcasing world-class travel, interior design, custom home building and architecture, as well as a variety of other topics of interest. Supported by a strong senior management team, professional associate publishers, production coordinators and a top-notch creative team of photographers, writers, and graphic designers, the company produces only the very best quality of these keepsake publications. Look for our complete portfolio of books at www.panache.com.

We are proud to introduce to you the Panache Partners team that made this publication possible.

John A. Shand
John is co-founder and owner of Panache Partners and applies his 25 years of sales and marketing experience in guiding the business development activities for the company. His passion toward the publishing business stems from the satisfaction derived from bringing ideas to reality. "My idea of a spectacular home includes an abundance of light, vibrant colors, state-of-the-art technology and beautiful views."

Brian G. Carabet
Brian is co-founder and owner of Panache Partners. With more than 20 years of experience in the publishing industry, he has designed and produced more than 100 magazines and books. He is passionate about high quality design and applies his skill in leading the creative assets of the company. "A spectacular home is one built for entertaining friends and family because without either it's just a house...a boat in the backyard helps too!"

Barbara Ballinger
Barbara Ballinger spent her first eight working years as a writer/editor at *Conde Nast's House & Garden Guides* magazine. She enjoys seeing the work of the fine design professionals throughout the Heartland. To her, a spectacular home is one that reflects her identity and incorporates her favorite possessions— baby grand piano, two dollhouses I lovingly built and furnished, antique quilts and weathervanes and photos of my darling grown daughters, other family, and friends galore!

Martha Morgan Cox
Martha is the Senior Associate Publisher in Texas for Panache Partners. She is a wanna-be-designer trapped in a publisher's body while living vicariously through the amazing designers that she meets each day. She remembers the flame for her design passion igniting when she was only five years old. It started with an elaborate doll house design and never stopped. "A spectacular home is where your family and friends are. But, it never hurts to be surrounded by yummy fabrics and fabulous design!"

Steven M. Darocy
Steve is the Executive Publisher of the Northeast Region for Panache Partners. He has over a decade of experience in sales and publishing. A native of western Pennsylvania, he lived in Pittsburgh for 25 years before relocating to his current residence in Dallas, Texas. Steve believes family is what makes a home spectacular.

Additional Acknowledgements

Project Management	Carol Kendall and Beverly Smith.
Graphic Designers	Mary Elizabeth Acree, Emily Kattan and Michele Cunningham-Scott.
Production Coordinators	Laura Greenwood, Kristy Randall and Jennifer Lenhart.
Editors	Elizabeth Gionta, Rosalie Wilson and Aaron Barker.

The catalog of fine books in the areas of interior design and architecture and design continues to grow for Panache Partners, LLC. With more than 30 books published or in production, look for one or more of these keepsake books in a market near you.

Spectacular Homes Series

Published in 2005
Spectacular Homes of Georgia
Spectacular Homes of South Florida
Spectacular Homes of Tennessee
Spectacular Homes of Texas

Published or Publishing in 2006
Spectacular Homes of California
Spectacular Homes of the Carolinas
Spectacular Homes of Chicago
Spectacular Homes of Colorado
Spectacular Homes of Florida
Spectacular Homes of Michigan
Spectacular Homes of the Pacific Northwest
Spectacular Homes of Greater Philadelphia
Spectacular Homes of the Southwest
Spectacular Homes of Washington, DC

Other titles available from Panache Partners

Spectacular Hotels
Texans and Their Pets
Spectacular Restaurants of Texas

Dream Homes Series

Published in 2005
Dream Homes of Texas

Published or Publishing in 2006
Dream Homes of Colorado
Dream Homes of South Florida
Dream Homes of New Jersey
Dream Homes of New York
Dream Homes of Greater Philadelphia
Dream Homes of the Western Deserts

Order two or more copies today and we'll pay the shipping.

To order visit www.panache.com
or call 972.661.9884.

Creating Spectacular Publications for Discerning Readers

Index of Designers

DESIGNER LEAH A. BAUER, MORGAN/BAUER DESIGN GROUP LLC, page 17

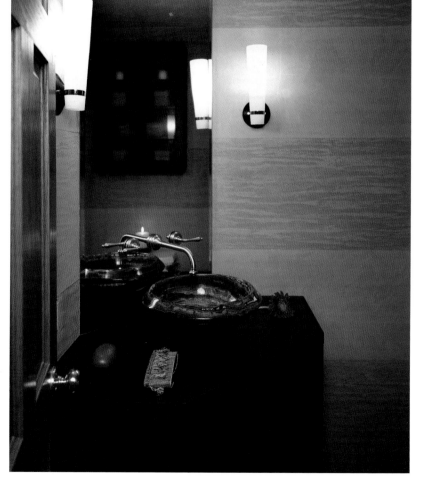